Ancient
Greece

| | | || BRIEF HISTORIES ||| | |

Ancient Greece

ELLIE MACKIN ROBERTS

SEVEN DIALS

First published in Great Britain in 2024 by Seven Dials,
an imprint of The Orion Publishing Group Ltd
Carmelite House, 50 Victoria Embankment
London EC4Y 0DZ

An Hachette UK Company

1 3 5 7 9 10 8 6 4 2

Copyright © Ellie Mackin Roberts 2024

The moral right of Ellie Mackin Roberts to be identified as
the author of this work has been asserted in accordance
with the Copyright, Designs and Patents Act of 1988.

All rights reserved. No part of this publication may be
reproduced, stored in a retrieval system, or transmitted
in any form or by any means, electronic, mechanical,
photocopying, recording, or otherwise, without the
prior permission of both the copyright owner and the
above publisher of this book.

A CIP catalogue record for this book is
available from the British Library.

ISBN (Hardback) 978 1 3996 2255 4
ISBN (eBook) 978 1 3996 2256 1
ISBN (Audio) 978 1 3996 2257 8

Printed in Great Britain by Clays Ltd, Elcograf, S.p.A

www.orionbooks.co.uk

To Sofia and Catherine

Ellie Mackin Roberts is an ancient historian who works on ancient Greek religious practices, and the way that people interacted with and reacted to the gods and their beliefs. She is a Research Fellow at the University of Bristol, and took her PhD in Classics at King's College London.

CONTENTS

INTRODUCTION

The legacy of ancient Greece has left an indelible mark on human civilisation – directly in the case of the Global North, and sometimes indirectly on the Global South, particularly through later colonial and cultural expansion and the empire building of the late 16th to early 20th centuries. From the soaring, perfectly proportioned columns of the Parthenon to the timeless verses of Homer and the philosophy of Plato, the contributions of this remarkable culture continue to resonate through the ages, shaping our understanding of art, literature, philosophy, science and politics. With their insatiable curiosity, innovative spirit and passion for excellence (as well as the ability to take influence from a wide range of other cultures), the ancient Greeks laid the foundations for much of what we consider the bedrock of thought and achievement in the Global North.

The story of ancient Greece is a sweeping epic, spanning over a millennium of history and encompassing a vast geographic expanse. From the dawn of the Bronze Age to the twilight of the Hellenistic era, the Greeks created civilisations that were deeply rooted in tradition and astonishingly dynamic in their ability to adapt

and innovate. The timeline of ancient Greek history is punctuated by pivotal events and transformative periods that shaped the course of not only Greek civilisation but also the broader Mediterranean world.

The Bronze Age (c. 3000–1100 BCE) saw the rise of the first great Greek civilisations, the Minoans and the Mycenaeans. The Minoans, centred on the island of Crete, developed a sophisticated maritime culture renowned for its vibrant frescoes, intricate metalwork and sprawling palace complexes. The Mycenaeans, based on the Greek mainland, were a warrior society immortalised in the epic poems of Homer. The collapse of these civilisations around 1100 BCE ushered in a period of economic decline that lasted for several centuries and had wide-ranging impacts on population numbers, health, agriculture and art and architecture.

The Archaic period (c. 800–480 BCE) witnessed the re-emergence of Greek civilisation and the birth of the *polis*, or city-state, as the fundamental unit of Greek political and social life. This era saw the rise of Greek colonisation, with Greek settlers establishing new cities throughout the Mediterranean and Black Sea regions. The Archaic period also marked the beginning of Greek literature, with the composition of the Homeric epics and the works of Hesiod. In art and architecture, the Greeks developed the distinctive styles that would define

their cultural aesthetic, including the birth of the Doric and Ionic orders.

The Classical period (c. 480–323 BCE) is often considered the 'golden age' of ancient Greece, a time of unparalleled cultural, intellectual and political achievement. This period began with the Persian Wars (499–449 BCE), in which the Greeks, led by the city-states of Athens and Sparta, successfully defended their homeland against the mighty Persian Empire. The aftermath of these wars saw the rise of Athens as a dominant power in the Greek world, ushering in the era of Athenian democracy and cultural supremacy. Under the leadership of Pericles (c. 495–429 BCE), Athens experienced a cultural and intellectual flowering that would leave a lasting mark on Western civilisation. The Parthenon, the iconic temple dedicated to Athena, was constructed on the Acropolis, while the plays of Aeschylus, Sophocles and Euripides enthralled audiences in the Theatre of Dionysus. The philosophies of Socrates, Plato and Aristotle laid the foundations for Western thought, while the histories of Herodotus and Thucydides set the standard for historical inquiry.

The Classical period also saw the rise of Sparta as a military power, culminating in the Peloponnesian War (431–404 BCE), a devastating conflict that pitted Athens against Sparta and their respective allies. The war ended in

Sparta's victory, but at a tremendous cost to Greek unity and prosperity. The fourth century BCE saw the rise of Macedon, a kingdom to the north of Greece, under the leadership of Philip II and his son Alexander the Great. Alexander's conquests (334–323 BCE) brought the Greek world to its greatest territorial extent, stretching from the Balkans to the borders of India.

The Hellenistic period (c. 323–31 BCE) began with the death of Alexander and the division of his empire among his generals. This era saw the spread of Greek culture and language throughout the Mediterranean and Near East and the rise of new cultural centres, such as Alexandria in Egypt. The Hellenistic period was marked by advances in science, mathematics and technology, as exemplified by the work of scholars such as Euclid, Archimedes and Eratosthenes. The period also saw the development of new philosophical schools, such as Stoicism and Epicureanism, which sought to provide answers to life's great questions. The Hellenistic period came to an end with the rise of Rome as a dominant power in the Mediterranean. The Roman conquest of Greece, completed in 146 BCE with the sack of Corinth, brought an end to Greek political independence but not to Greek cultural influence. Indeed, the Romans were deeply fascinated by Greek culture and sought to emulate and adapt it to their own ends. The Roman poet Horace

famously declared, 'Captive Greece took captive her fierce conqueror', a testament to the enduring power of Greek cultural achievements.

Throughout this long and complex history, the ancient Greeks made enduring contributions to virtually every field of human endeavour. In the realm of literature, the Greeks produced works of unparalleled beauty and depth, from the epic poetry of Homer to the lyric verse of Sappho, from the histories of Herodotus and Thucydides to the philosophical dialogues of Plato. Greek drama, with its exploration of timeless themes of love, loss, fate and the human condition, laid the foundation for the Western theatrical tradition. In the visual arts, the Greeks achieved a level of naturalism and idealisation that would inspire artists for centuries to come. The sculptures of Phidias and Praxiteles, with their emphasis on proportion, balance and the idealised human form, set the standard for Classical art. The frescoes and mosaics that adorned Greek homes and public spaces displayed a keen eye for colour, composition and storytelling. Greek architecture, with its emphasis on harmony, proportion and balance, left a continuous mark on building design globally. The Parthenon, with its perfect proportions and exquisite sculptural decoration, remains an enduring symbol of Greek cultural achievement.

In the realm of science and mathematics, the Greeks made groundbreaking discoveries that laid the foundation for modern scientific inquiry. Thales, Pythagoras and Euclid made fundamental contributions to geometry and mathematics, while Aristotle and Theophrastus pioneered the study of biology and natural history. Hippocrates and Galen made significant advances in medicine, establishing the principles of medical ethics and developing new methods of diagnosis and treatment. Greek philosophy, with its emphasis on reason, logic and the pursuit of truth, had a profound impact on Western thought. The Socratic method of inquiry, with its focus on questioning assumptions and seeking definitions, remains a cornerstone of philosophical discourse. Plato's Theory of Forms and his conception of the ideal state continue to inspire and provoke debate, while Aristotle's systematic approach to logic, metaphysics and ethics laid the groundwork for centuries of philosophical inquiry.

Beyond these intellectual and artistic achievements, the ancient Greeks also made significant contributions to the development of political thought and practice. The Athenian democracy, despite its flaws and limitations, represented a radical experiment in self-governance and political participation. The idea that citizens could have a say in the decisions that affected their lives, and that laws could be created and enforced through a process of

public deliberation and consensus was a revolutionary concept that would have far-reaching consequences for the development of Western political thought.

The legacy of ancient Greece extends far beyond the confines of the Mediterranean world. Through the spread of Greek culture and language during the Hellenistic period, Greek ideas and values were transmitted to the far corners of the known world, influencing the development of civilisations from the Indus Valley to the Nile Delta. The encounter between Greek and Roman culture, in particular, would have profound consequences for the development of Western civilisation, as the Romans adapted and built upon the achievements of their Greek predecessors.

In the centuries that followed the fall of the Roman Empire, the legacy of ancient Greece would be rediscovered and reinterpreted by successive generations of scholars, artists and thinkers. The Renaissance, with its rediscovery of Classical texts and its emphasis on humanism and individual achievement, owed much to the example of ancient Greece. The Enlightenment, with its emphasis on reason, science and progress, drew heavily on the intellectual traditions of the Greeks. Even in the modern era, the influence of ancient Greece can be seen in fields as diverse as literature, art, architecture, politics and philosophy.

The study of ancient Greece, then, is not simply an exercise in historical curiosity or nostalgia. Rather, it is an ongoing conversation with a civilisation that continues to shape our understanding of ourselves and our place in the world. By engaging with the ideas, values and achievements of the ancient Greeks, we gain a deeper appreciation for the enduring power of human creativity, curiosity and the pursuit of excellence. The legacy of ancient Greece is, in many ways, the legacy of human civilisation itself – a testament to the persisting power of the human spirit to strive, to create and to leave a lasting mark on the world.

I.

Philosophy and Intellectual Pursuits

The roots of Western philosophy can be traced back to
the extraordinary flourishing of intellectual activity in
ancient Greece from the sixth century BCE onwards.
Over a few generations, a succession of Greek thinkers
developed a set of revolutionary concepts and methods
that would profoundly influence the subsequent course
of not only philosophical thought but also medicine,
science, mathematics and artistic innovation. From the
early Pre-Socratic philosophers who sought the funda-
mental principles underlying the order of the cosmos
to the groundbreaking investigations of Socrates, Plato
and Aristotle into ethics, politics, metaphysics and
logic, the ancient Greeks laid the essential founda-
tions for the Western tradition of philosophical inquiry.
Their abiding legacy was to bequeath to us the very
idea of philosophy itself – the love of wisdom and
the uncompromising pursuit of truth through rational
argument and discussion. This chapter will explore
the major movements and thinkers that defined this

golden age of philosophical activity and reflect on their enduring significance.

The Pre-Socratic Philosophers

The first stirrings of philosophical activity in the Greek world did not occur in the cultural centre of Athens, but in Ionia, a region of Greek settlements located on the coast of present-day Turkey. Here, in the thriving mercantile city of Miletus, the Pre-Socratic thinker Thales took the first crucial steps towards a rational, naturalistic understanding of the world. Breaking with the mythological tradition of explaining natural phenomena by reference to the machinations of anthropomorphic gods, Thales boldly proposed that the fundamental basis of all things was a single material substance – water. While this answer may appear quaint to modern scientific sensibilities, the real significance of Thales's work lies in his methodological approach. He was the first European thinker to advance a rational, materialistic account of the cosmos based on empirical observation and logical reasoning.

Thales's intellectual successors in Miletus, Anaximander and Anaximenes, continued the tradition of rational speculation into the ultimate nature of reality. Anaximander suggested that the basis of the cosmos was an unspecified, boundless substance called the *apeiron*, while Anaximenes identified air as the primary element. With

these competing theories, the Milesian school inaugurated a central debate that would occupy subsequent generations of Pre-Socratic philosophers – the quest to identify the fundamental constituent of the physical world.

Among these early Ionian thinkers, perhaps the most striking and enigmatic figure was Heraclitus of Ephesus. In a series of gnomic, paradoxical statements, he articulated a world view radically at odds with the assumptions of his predecessors. For Heraclitus, the essence of reality was not stability but flux – a ceaseless process of transformation and change symbolised by the element of fire. 'No man ever steps in the same river twice', goes his most famous saying, encapsulating a vision of the world as a constant interplay of opposing forces in which all permanence is illusory. Heraclitus saw unity in diversity, reason in apparent randomness: 'The way up and the way down is one and the same'.

The early Ionians were material monists, attempting to explain the diversity of natural phenomena in terms of modifications or transformations of a single basic substance. A contrasting perspective was advanced by the Eleatic school, whose doctrines found their most precise expression in the surviving fragments of Parmenides's philosophical poem. Parmenides's work opens with an allegory in which the narrator is conveyed by horse-drawn chariot from the familiar world of night to a

transcendent realm of light, where a goddess reveals to him the nature of what truly is. In a line of argument that was to prove hugely influential for later philosophers, Parmenides reasoned that genuine reality must be eternal, unchanging and indivisible – a perfect sphere of homogeneous Being, to which the notions of past and future, multiplicity and change, do not apply. Our everyday experience of a world of transient, mutable entities is consigned to the realm of mere opinion or illusion.

Parmenides's brilliant disciple Zeno deployed a battery of ingenious paradoxes to reinforce the Eleatic world view by exposing the absurdities that result from belief in change and plurality. Zeno's most famous paradox purports to show that swift-footed Achilles can never overtake a slow-moving tortoise if the tortoise is given a head start. By the time Achilles reaches the tortoise's starting point, it will have crawled a little way further; by the time Achilles reaches that point, the tortoise will have advanced again, and so on – the conclusion being that motion is impossible. Though not intended as serious logical brainteasers, Zeno's paradoxes highlighted deep perplexities surrounding our concepts of space, time and infinity.

A more robustly pluralistic conception of reality was defended by the Atomist school, whose luminaries included Leucippus and Democritus. Accepting the cogency of Parmenides's rejection of true coming-into-being and

passing-away, the Atomists sought to preserve the phenomena of change and multiplicity by hypothesising the existence of innumerable, eternal, indivisible particles moving in an infinite void. On this view, the diverse array of entities and properties we encounter in experience is simply the product of the ever-shifting arrangements and combinations of these qualitatively distinct atoms, as they collide and interact according to fixed mechanical laws.

The Pre-Socratic philosophers comprised several separate groups, and their specific doctrines diverged widely. But what united them was the pioneering commitment to explicating the workings of nature in terms of rational, empirical principles, without recourse to supernatural entities or mythological narratives. In seeking to uncover the underlying regularities and causes at work in the cosmos, they took the first fundamental steps towards the scientific world view. At the same time, their bold speculations and conceptual innovations laid the groundwork for the more anthropocentric and ethically oriented approach to philosophy that would be developed by Socrates and his followers.

Socrates and Plato

The pivotal figure in the transition from the Pre-Socratic focus on cosmology and natural philosophy to a more humanistic and practically engaged conception of the

philosophical enterprise was Socrates. Though we have no writing from Socrates himself, his personality and thought were vividly immortalised in the dialogues composed by his student Plato, and the historian Xenophon. In Plato's philosophical works, we encounter a Socrates who is a shabby, satyr-like, yet magnetic figure, living an ascetic life on the streets of Athens and engaging in philosophical discussion with all comers, from statesmen and sophisticates to humble craftsmen and precocious youths.

Socrates's philosophical interests were emphatically ethical in character. He was preoccupied with questions concerning the nature of virtues, such as justice, piety and courage, and the relationship between virtue and human flourishing or happiness. His approach to these issues cantered on a distinctive method of inquiry known as the 'elenchus' or cross-examination, which aimed to expose the flaws and inconsistencies in his interlocutors' opinions, and to guide them towards a more coherent and rationally grounded understanding. By revealing the hollowness of received wisdom and unexamined assumptions, Socrates sought to spur his fellow citizens to a process of critical self-reflection and a commitment to pursuing truth through reasoned arguments, rather than accepting false conceit of knowledge. 'The unexamined life is not worth living for a human being', he notoriously declares in Plato's *Apology*.

While Socrates deployed the elenctic method primarily in the service of ethical inquiry, his student Plato harnessed it to develop a systematic metaphysical vision of breathtaking scope and originality. The cornerstone of Plato's thought is his theory of transcendent Forms or Ideas, eternal and immutable essences which exist in a realm accessible to pure reason, and of which the mutable objects of the sensory world are but imperfect copies or instantiations. On Plato's account, when we recognise a particular vase or painting as beautiful, we do so in virtue of its 'participation' in the perfect, self-sufficient Form of Beauty. And only the philosopher, who has succeeded in moving beyond mere sensory experience to grasp these abstract, mind-independent structures directly through contemplative activity, can be said to possess genuine knowledge.

Plato's theory of Forms underpins his influential conception of knowledge and education, memorably elaborated through the famous allegory of the Cave in Book Seven of his masterwork *The Republic*. This compelling image compares the ordinary human condition to that of prisoners shackled in a dim subterranean chamber, able to see nothing but the flickering shadows of puppets projected on the wall before them. Only through arduous philosophical training and reflection can the prisoner (representing the aspiring philosopher-king) ascend into

the sunlit realm of true understanding, a transformative journey symbolising the mind's ascent from the world of mere opinion to the world of timeless, transcendent Forms. Plato's soaring metaphysical vision would exercise a profound influence on the subsequent history of Western thought. But it was also vigorously contested by his greatest student Aristotle who developed a sophisticated naturalistic system that sought to comprehend reality in terms of the immanent, structural features of the physical world itself. Where Plato saw the sensory realm as but a shadowy reflection of immaterial archetypes, Aristotle located the essences of things in their intrinsic forms, the intelligible patterns that define and render comprehensible their natures as the particular substances they are.

Aristotle

The pivotal figure in the development of Greek philosophy, however, was undoubtedly Aristotle. A student of Plato's Academy until the former's death, Aristotle's thought demonstrates a resolute commitment to the primacy of empirical observation and inductive reasoning. Where Plato exalted the immaterial realm of transcendent Forms as the ultimate source of truth, Aristotle insisted that genuine understanding must be grounded in a meticulous study of the natural world in all its concrete particularity.

This conviction led him to undertake pioneering investigations across a vast range of disciplines, from biology and physics to ethics, politics and aesthetics.

In his logical treatises, collectively known as *The Organon*, Aristotle developed the first systematic theory of deductive inference, centred on the syllogism. His formulation of the basic rules of logical validity, and careful analysis of the interrelations between necessity, possibility and contingency, would provide the framework for the study of logic well into the modern era. No less groundbreaking was his metaphysical theory of hylomorphism, which sought to explain the nature of reality in terms of the dynamic interplay between matter (*hyle*) and form (*morphe*). On this view, the intelligible structure or essence of a thing is immanent within it as its intrinsic formal cause – an idea that stood in sharp contrast to Plato's theory of separately existing, transcendent Forms.

Aristotle also turned to the study of the good life and the ideal society. In his *Nicomachean Ethics,* he argued that human flourishing consists in the cultivation of moral and intellectual virtue, chief among which is wisdom (*sophia*) – the perfection of philosophical contemplation. But while the supreme human calling is a life of *theoria* or pure thought, Aristotle recognised that we are fundamentally social and political animals. In his *Politics*, he surveyed the full spectrum of actual and possible

constitutional forms, from democracy and oligarchy to aristocracy and monarchy, in an effort to discern the strengths and weaknesses of each as a means of promoting the common good and realising our nature as 'rational animals capable of logos'.

Aristotle's voluminous research into the teeming diversity of the natural world, based on scrupulous observation and collection of empirical data, also marked a signal advance in scientific method. In his *History of Animals*, Aristotle amassed a wealth of zoological information gathered from interviews with fishermen, beekeepers and other tradesmen with intimate knowledge of the creatures in their purview. On the basis of these painstaking investigations, he was able to produce astonishingly accurate accounts of marine biology, including detailed descriptions of the cephalopods and the embryological development of the hound shark. Aristotle's anatomical studies further led him to the crucial recognition of the heart's centrality in the vascular system – a major milestone in the history of medicine.

The sheer breadth and depth of Aristotle's achievements is astounding. By bringing the critical lens of reason to bear on every field of inquiry, from the natural sciences to metaphysics, logic, ethics, politics and poetics, he laid the foundations for over two millennia of 'Western' thought. As Dante memorably put it, Aristotle was 'the

master of those who know' – *il maestro di color che sanno*. While his scientific theories have long been superseded, the fundamental questions he raised, his emphasis on empirical observation and logic, and his insistence on following the argument wherever it leads, remain the hallmarks of the philosophical enterprise.

The extraordinary burst of philosophical activity in ancient Greece between the 6th and 4th centuries BCE represents one of the decisive episodes in the intellectual history of humanity. In the works of thinkers from Thales to Aristotle, we find the emergence of a uniquely potent fusion of rational argumentation, conceptual analysis and empirical investigation that would set the agenda for much subsequent philosophical and proto-scientific activity. While the positive theories advanced by these pioneering figures have for the most part been superseded, the real nature of their achievement lay in the example they provided of free, critical inquiry, unconstrained by dogmatic authority and guided by an overriding commitment to following the argument where it leads. By elevating logos or reason to the ultimate arbiter of truth and falsehood, the Greek philosophers established the fundamental conceptual framework and methodological template for the Western tradition of rational thought – an inheritance which continues to nourish and inspire minds to the present day.

The ancient Greek philosophers made groundbreaking contributions to the development of 'Western' thought, laying the foundations for rational inquiry, scientific investigation and the pursuit of wisdom. From the early pre-Socratic thinkers who sought to understand the fundamental principles of the cosmos to the profound insights of Socrates, Plato and Aristotle into ethics, metaphysics and the nature of reality, the Greeks established philosophy as a rigorous discipline based on logical argumentation and critical analysis. Their intellectual achievements not only shaped the course of 'Western', or Global North, philosophy but also had a profound impact on the development of literature, art, politics and other aspects of Greek culture, which will be explored in the chapters to come. The enduring legacy of ancient Greek philosophy lies in its commitment to the uncompromising pursuit of, through reason and dialogue, a spirit of inquiry that continues to inspire and guide us in our quest for understanding the world and our place within it.

2.

Art, Literature and Aesthetics

The ancient Greeks' contributions to art, literature, and aesthetics form the bedrock of what we now call 'Western' cultural heritage. Their innovative approaches to sculpture, architecture, pottery, and literature reflected not only the values and beliefs of their collective city-states, but also pushed the boundaries of human creativity and expression. This chapter delves into the rich tapestry of Greek artistic achievement, exploring how their works evolved from the stylised forms of the Archaic period to the naturalistic dynamism of the Classical era. From temples to public buildings adorned with sculptures that brought myths to life, the narratives painted on everyday pottery, and the great works of literature and drama that still resonate with audiences today – Greek art and literature were not merely aesthetic pursuits, but integral components of their religious, political, and social life.

Sculpture

Classical Greek sculpture is rooted in a deep appreciation for the human form and a commitment to capturing its essence in stone. It is the idealised representation of the human body, emphasising balance, proportion and symmetry; not merely an aesthetic pursuit but also a reflection of Greek ideas about the gods, society, beauty and harmony. The distinctive stylisation and idealised perfection seen in early Greek figural sculptures, such as *kouroi* (male youth, singular *kouros*) and *korai* (female youth, singular *kore*) figures reflect important Egyptian influences. Contact through trade exposed Greek artists to Egyptian statuary and artistic conventions that valorised youth, symmetry and precise compositional arrangements. The Greeks would add their own signatures, like contrapposto pose – where the weight of the body is placed on one leg, causing the shoulders and arms to rest at opposing angles and the hips to tilt offset from the head and torso, creating an 'S'-shaped stance that makes the figure look more dynamic and lifelike. The Egyptian emphasis on monumental, stylised figures with frontal torso, indented eyes and one foot striding forward directly shaped the emergence of Greek monumental sculpture traditions in the 7th and 6th centuries BCE. The Greeks adapted Egyptian artistic ideas while also infusing their own aesthetic of dynamism and humanism.

Yet the seminal Egyptian influence is apparent across early Greek stone figurative masterpieces.

The widespread *kouroi* statues of the Archaic period encapsulate the Greek value of idealised male youth through their nude athletic frames, meticulously crafted details and frontal stances imbued with values praised in society, including confidence, strength and focus. Yet while their bodies stand poised for movement, any sense of dynamism is restrained. Their stiff limbs, clenched fists and outward gaze, though seemingly attentive to the outside world, also convey detachment and self-containment – the *kouros* figure is entirely self-involved. With the emergence of the Severe Style in the early Classical period, we witness cracks forming in this self-containment. The Severe Style begins the departure from the 'emotionless' faces of the Archaic period sculptures and hails early attempts at more naturalised features and postures. The slightly bent knees and arms lifted away from the torsos suggest latent tension, hinting at an interior life beneath the composed exterior and demonstrating awakened self-consciousness. Where the Archaic statues present the idealised image of youth for public consumption, the Severe sculpture of the early Classical period implies that these young men have emotional and social lives that are not always in line with civic and social expectations. The evolving styles show not

only aesthetic but thematic progression in presenting the complexities of human experience out of the shell of strict canonical forms.

As the form of sculpture progresses, images become more active and realistic and present a more complex picture of the individuals who are being represented. As figures begin to twist and turn, frozen mid-action, their bodies convey triumph and agony, power and vulnerability simultaneously. The emotional intensity created by sinuous forms reflects humanity's internal struggles writ large. This shift is perhaps best visualised on the pediments (the triangular space at the front of rear of buildings with pitched rooves) of the Temple of Athena at Aphaia, on the island of Aegina. The pediments at each end of the temple contain similar figures, yet the west pediment is undertaken in a distinctly late archaic style and the east pediment in an early Classical style. The differences are striking, with the older statues appearing emotionless and wooden – a fallen soldier grasps an arrow that has pierced his chest while looking at the viewer with a strikingly calm face and lightly upturned mouth (the so-called 'archaic smile'). At the opposite end of the temple, in the Classical style, a fallen warrior looks towards the ground, using his shield for stability, his face contorted with anguish, his body twisted unnaturally. There is, according to the Glyptothek Museum in

Munich, where the pedimental sculptures now live, only twenty years between these figures, and yet the stylistic and emotive progression is enormous.

The Athenian sculptor Myron, active in the mid-fifth century BCE, gave us one of the most enduring images of sporting excellence in the *Discobolus* (the 'Discus Thrower'). The sculpture presents a pivotal thematic shift from external stillness to inner dynamism. The twisting bronze figure epitomises the Classical period's fascination with motion and emotion. Yet the visible strain of *Discobolus*'s body shows more than sheer physical exertion; it symbolises the depth of human feeling bursting forth from within after being repressed for centuries by the external stillness of *kouroi* forms. *Discobolus* does not merely twist; he contorts with muscular agony while eyes are narrowed in focused determination. Even the perfectly proportioned athlete being torn asunder traces how the human experience bridges outer order with chaotic inner worlds in an ever-shifting balance.

Pottery

Pottery is one of the most abundant forms of art from the ancient world, due to its myriad uses and relative low cost. The Greeks excelled at pottery techniques to produce vessels in an array of distinctive shapes for different functions. Bulbous *amphora* jars stored and

transported oil, wine and foodstuffs both within Greece itself and via trade to regions including the Levant, the Black Sea, North Africa and southern Italy. *Kraters*, or mixing bowls, often with elaborately decorated lips and handles, mixed water and wine at banquets. More squat *hydriae* jars held water, and pitchers poured libations at ceremonies. For drinking wine, the deep *kylix* cups with two horizontal handles allowed symposium attendees to enjoy this fermented beverage. The globular *aryballos* pot stored perfumed oil that Greeks applied after athletic training, bathing or for daily wear. The smaller *oinochoe* jugs dispensed small portions of wine. Though durability and capacity for storage or serving varied across shapes, all pottery followed a uniform firing process in kilns to produce vessels that were both practical for daily tasks and aesthetically striking. The common technique united function with form.

The styles and techniques of painted decoration that covered these pots evolved over centuries. During the Geometric period dating back to 900 BCE, artists decorated vessels with precise lines and geometric shapes, evoking symmetry and order, even while highlighting the emotion of human life, often in funerary scenes of mourning. In such scenes, abstracted human figures with triangular bodies are shown in poses indicating mourning, including humans with their arms raised above their

heads. The figures are arranged around an image of the deceased shown lying on the funeral pyre. The iconic silhouette style of the seventh century Black-figure era allowed potters to depict elaborate scenes from mythology with heroic figures etched in clay silhouettes against the black glossy backgrounds. Red-figure pottery then rose to prominence around 530 BCE by essentially inverting the colour scheme to showcase red figures with black backgrounds, permitting even more anatomical realism and emotional expressiveness in characters. Whether decorating *amphorae* storage vessels or *kylix* drinking cups, Greek pottery typically served both utilitarian and artistic aims, functioning as vessels for carrying wine, oil or funerary ashes while also providing surfaces for symbols, myths or snapshots of everyday life that provided visual storytelling. The diversity of themes, from intricate battle narratives to intimate wedding preparations, reveals pottery's role as a mediator between the worlds of gods and mortals.

These elaborate scenes can provide a vivid window into Greek mythology, culture and daily life. Given the Greeks' belief in various gods and heroes, a frequent theme depicted is myths and legendary narratives like Heracles's heroic labours, the tragedy of the Trojan War, or famous battles between men and monsters like the story of Theseus defeating the Minotaur. Vessels used at

the symposium – essentially drinking parties – showed scenes of revelry and celebration, showcasing images of feasting, dancing and libations honouring Dionysus. Other vessels highlight religious practices, from ritual-istic burials to images of offerings left at sanctuaries and temples, conveying the Greeks' devotion to the gods. Equally abundant are slice-of-life vignettes with women performing domestic chores like weaving and fetching water while warriors return from battle – articulating gender roles of the time.

Architecture

Ancient Greek temples were often adorned with elabo-rate sculptural programmes that carried strong thematic meaning for civic and religious life. The Parthenon frieze depicting the Panathenaic procession, for example, articu-lated themes of military strength and pious tribute to Athena in Athens at the time (discussed in more detail below). Likewise, the Temple of Zeus sculptures illus-trated contests between gods and giants, underscoring mortal struggle and the triumph of order over chaos. Another common theme was the battle between Lapiths (a community of mortal Greeks from Thessaly) and Centaurs, symbolising the Greeks' conceptions of civilised society defeating animalistic and uncouth forces. While stylistic details certainly evolved, the thematic emphasis

on military power, civic order, piety and justice seen in architectural sculpture remained remarkably consistent as an embodiment of Greek values. Through these ornate stone themes, the temples literally upheld the social and cosmic order.

Technically, Greek architecture is distinguished by the formal development of three different orders – Doric, Ionic and Corinthian – each with their own distinctive proportions and decorative details. The Doric order emerged on the Greek mainland and western colonies in the seventh century BCE, characterised by sturdy columns without a base, simple capital tops and thick, triglyph-decorated entablatures. The smaller scale but more ornately decorated Ionic order developed near-simultaneously in eastern Greek islands like Ionia, featuring elegant voluted capitals and ornate continuous friezes. The Corinthian order came last in the fourth century BCE, fusing an Ionic-style base and capital with an elaborate new acanthus leaf capital to create the most ornamented and grandiose variant – supposedly this was developed when sculptor Callimachus took inspiration from a basket of acanthus leaves adorning the grave of a young girl. While the exact ratios, column heights and supplementary decoration differed, all three orders utilised harmonious geometry. These 'orders' still adorn many buildings to this day, from personal homes to public

buildings, churches and museums. They have become ubiquitous throughout the Global North.

Several Greek temples stand out for their immense size, ornate details and significance in religious and civic life. The Erechtheion, an Ionic order temple on the Athenian Acropolis, stands as a testament to the ingenuity and adaptability of Classical Greek architecture. Made between 421 and 406 BCE, the Erechtheion's asymmetrical layout and use of both Ionic and Caryatid (where the columns are made of *kore* statues) columns demonstrate how Greek architects could innovatively tailor their designs to accommodate the uneven terrain and complex religious requirements of the site. The temple's eastern façade, adorned with an elegant Ionic portico, contrasts with the southern Caryatid porch, where six sculptural maiden figures gracefully support the entablature. This unusual combination of architectural elements, along with the building's intricate frieze (of which little remains) and ornate mouldings, exemplifies the Athenian's ability to create a harmonious and visually stunning monument that seamlessly integrated into its sacred surroundings. What sets the Erechtheion apart from other Classical period temples is its remarkable adaptation to the steep, irregular slope of the north side of the Acropolis. The architects skilfully designed the building to embrace the natural contours of the site, with the eastern and northern

porches situated at a higher elevation than the rest of the building. This innovative approach not only allowed the temple to be seamlessly integrated into the landscape but also created a dynamic interplay of levels and spaces that would have enhanced the visitor experience of the site. The Erechtheion's unique design speaks to the innovative spirit of Greek architects.

The Temple of Zeus at Olympia, built in the early Classical period around 456 BCE, epitomises the grandeur and sacred significance of Greek religious architecture. This colossal Doric temple, designed by the architect Libon of Elis, housed one of the Seven Wonders of the Ancient World – the magnificent gold and ivory statue of Zeus crafted by the renowned sculptor Phidias. The temple's monumental scale, with its impressive façade featuring six columns across and thirteen down each side, conveyed the power and majesty of the king of the gods. The metopes, carved with the Twelve Labours of Heracles, and the pedimental sculptures depicting the mythical chariot race between Pelops and Oenomaus, further emphasised the temple's religious and cultural importance. Although now largely in ruins due to earthquakes and the ravages of time, the Temple of Zeus at Olympia remains an enduring symbol of the heights of artistic achievement and sacred devotion reached by the ancient Greeks in their architectural endeavours. Its legacy, as a centre of religious worship

and a testament to the fusion of human skill and divine inspiration, continues to captivate and inspire admirers of Classical architecture to this day.

Ancient Greek art and architecture blended down-to-earth human focus with ideals and outside influence. Lifelike statues of young men based on standard measurements stressed human proportions while also incorporating Egyptian conventions like frontal poses and bodily movement. Yet this human-centred art intertwined civic and religious roles. Many *kouros* and *kore* statues were used as grave markers or offerings to the gods, and these influenced the way that architectural sculpture developed. By combining human representation, rational principles and reverence towards deities, Greek artworks and buildings cemented cultural values, joining community obligation with free thinking. The harmonious architectural forms, cosmologic decoration motifs and public ritual images fused disparate experiences into a democratic ethos that promoted excellence resting upon shared beliefs. This art was proudly public while drawing eclectically from abroad, especially Egypt. Such images celebrated both the human potential and its connection to the divine, and this is true for both the artists whose craft was under the domain of the gods and the people who were represented by the statues themselves.

The Parthenon

Crowning the Acropolis of Athens stands the Parthenon, a building dedicated to the city's patron goddess, Athena, which stands as a thank-offering for the Greek – and especially Athenian – victory over the Persians. Built between 447 and 432 BCE under the direction of the statesman Pericles, this architectural marvel is considered the epitome of Classical Greek architecture and a symbol of the 'golden age' of Athens. The Parthenon was designed by the architects Ictinus and Callicrates, while the sculptor Phidias oversaw the elaborate sculptural decoration. The building is mixed order, with eight Doric columns on the short sides and seventeen on the long sides, but with Ionic columns in the interior of the treasure storage room at the back. The columns, each standing over ten metres tall, taper gently towards the top, creating an optical illusion of perfect straightness.

The building's most striking feature is its sculptural frieze, which runs around the top of the exterior walls. This continuous band of relief sculpture is 160 metres long and a little over a metre in height. It is carved in high relief and depicts the Panathenaic procession. The Panathenaia was a festival held every year in honour of Athena including athletic and music contests, held every four years. Each year Athenians would march from the city gates up to the Acropolis in a grand procession. The frieze

depicts this cavalcade of figures, including horse riders, musicians, people carrying water jars, marshals, sacrificial animals, women and girls with libation bowls and jugs and – at the very front – the gods and an intriguing scene that shows two younger girls, the Priestess of Athena, an older man (who may be the Priest of Poseidon or the city's chief magistrate) and a young boy. The older man and the boy appear to be folding up a large piece of cloth, which most scholars think is the dress that is made as an offering for Athena each year and placed on her ancient olivewood statue. All these figures are rendered with exquisite detail, realism and individuality.

The east and west pediments of the Parthenon contained monumental sculptures depicting the birth of Athena at the east (or front) end and her contest with Poseidon for patronage of Athens at the west (or rear). Though these sculptures are now largely lost or destroyed, the few surviving figures, such as the reclining 'Theseus' from the west pediment, reveal the incredible skill of the ancient sculptors in rendering the human form with naturalism and dynamism.

Inside the Parthenon stood the colossal statue of Athena Parthenos, sculpted by Phidias. This awe-inspiring figure, at over 12 metres tall, was made of gold and ivory ('chryselephantine') and depicted the goddess in full battle regalia, holding a statue of Nike (goddess of

Victory) in her right hand and resting her left on her shield. Though the original statue is long lost, ancient accounts and small-scale replicas give us a sense of its grandeur and opulence.

Beyond its artistic merits, the Parthenon also serves as a testament to the mathematical precision and optical refinements employed by Greek architects. The building's seemingly straight lines are actually carefully calculated curves, a subtle adjustment to compensate for the human eye's tendency to perceive long horizontal lines as sagging in the middle. The columns also swell slightly in the middle (called 'entasis'), creating an impression of strength and vitality while still also appearing light and 'springy'. The Parthenon also reflects the interplay between sculpture and architecture that characterises much of Greek art. The building itself serves as a grand pedestal for the sculptural narratives that adorn its frieze, pediments and metopes – spaces within the building that lend themselves to artistic adornment. These sculptures, in turn, enhance and elevate the architectural form, creating a seamless integration of art and structure.

The Parthenon has endured a tumultuous history, serving as a church, a mosque and even an ammunition store over the centuries. In the early nineteenth century, Lord Elgin removed many of its sculptures and

transported them to the British Museum, where they remain a source of controversy and debate over repatriation. In many ways, the Parthenon encapsulates the spirit of ancient Athens at its zenith – a city that prized artistic excellence, intellectual inquiry and reverence for the divine. Its enduring legacy has influenced countless artists, architects and thinkers throughout history, making it a true icon of human civilisation.

Literature and Drama

Storytelling was integral to ancient Greek culture, from myths that explored the cosmos and human experience to historians chronicling past events. The Greeks pioneered recording chronicles of the past with Herodotus's *The Histories*, providing a mix of mythology and history combined in a wide-ranging telling of the Greco-Persian Wars. Thucydides further established history writing as a rational investigation separate from poetry. Yet Greek mythic storytelling coexisted with retelling history by offering cultural explanations of cosmic phenomena, and the different genres of literature worked together to articulate shared identities – whether those were about articulating citizenship, religious beliefs, cultural norms, societal roles or collective memory and heritage. The impulse for narrative circulation through oral traditions, dramatic performances, written records and visual arts ran

deep in Greek society as a means of transmitting cultural knowledge and traditions central to Greek conceptions of themselves. This reflected the interest in human drama, existential questions and communicating cultural values in creative, entertaining ways to each new generation.

The two epic poems attributed to the ancient Greek poet Homer, *The Iliad* and *The Odyssey*, stand as foundational pillars of 'Western' literature and remain profoundly influential works. Composed around the eighth century BCE, *The Iliad* tells the story of a pivotal event in Greek mythology – the end of the ten-year-long war between the Greeks and Trojans, including the rage of Achilles and the struggles of the Greek allied forces against Troy (the story of the Trojan War will be discussed in the next chapter). *The Odyssey* recounts the adventures of Odysseus, King of Ithaca and one of the heroes of the combined Greek forces, and his adventurous return voyage to his home of Ithaca after the war. Homer's works established the Homeric dialect as a basis of ancient Greek literary language and invented the dactylic hexameter meter that would become the heroic metre for future epics. This meter consists of six 'feet' per line, arranged in two sets of beats that often follow the pattern of long-short-short (dum-da-da). Many of the Greek gods and ideals about virtue, honour and heroism evident in Greek culture originate in Homer's

vivid narratives and characters. Even more universally, the symbolic tales of suffering, homecoming, loyalty and fate provide an archetypal human drama explored by every subsequent generation of artists and leaders shaped by Greek traditions. Through founding an epic narrative tradition focused on war and warriors, Homer provided a cornerstone text that deeply permeated Greek thought and culture.

Greek drama emerged in the sixth century BCE from performances associated with religious festivals honouring Dionysus, god of wine, drama, and ecstasy. The most famous playwrights working at the height of Classical Athens included Aeschylus, Sophocles, Euripides and Aristophanes. While tragedies like *Oedipus Rex* and comedies like *The Frogs* entertained audiences, they often explored deeper philosophical themes about justice, piety, power, war and the tension between individual and state. Both genres eventually relied on three actors and a chorus and followed poetic metres and structures. All the actors were male, even when playing female roles. Tragedies presented grave, emotive stories of figures destroyed by fatal flaws and circumstances, while satirical comedies inverted societal norms and parodied contemporary figures and events. Later sources tell us that each of the main playwrights added something to the development of drama; Aeschylus added the second and third actors

and amplified the role of the chorus; later, Sophocles introduced more complex characters and the addition of painted and decorated sets. Euripides broke conventions with his gritty realism and emotional intimacy. However, our later sources indicate that Sophocles introduced the third actor, while some of Aeschylus's plays – clearly written before Sophocles's career began – require it, demonstrating that we must be wary of the 'neatness' with which these later sources categorise advancements in the theatre. The bawdy irreverence of comedies like *The Clouds*, in which Aristophanes parodies the philosopher Socrates, shows drama's role as political and social commentary – which sometimes leads to censorship. Yet, whether making audiences weep or laugh, Greek drama became a fundamentally engrained ritual that encouraged reflection on community and existence at the very heart of the *polis*.

Greek lyric poetry first flourished around 650–480 BCE, with written versions recorded a few centuries after initial oral performances by travelling artist-poets. Lyric poetry expresses the personal thoughts and feelings of the poet rather than focusing on epic heroic narratives. Many poems were set to music, like Sappho's evocative, sensuous fragments on love written for young women. Pindar achieved great fame and wealth, composing victory odes for the Olympic Games and other major athletic

festivals, praising the victor's skill while reminding them that human accomplishment remains dependent on the favour of the gods. Other poets like Alcaeus and Anacreon echoed such themes, exploring politics, love, nature and celebration – articulating rich inner worlds. While the remnants of many lyric poets' works are fragmentary today, what remains testifies to their pioneering role in Greek literature through emotional intimacy paired with aesthetic experimentation in metre, vocabulary, structure and dialect. Their legacy continued resonating through Hellenistic times and beyond, laying artistic foundations for figures from Horace to John Keats to leverage creative expression to capture philosophical truths about fleeting human life.

The ancient Greeks' contributions to art, literature and aesthetics continue influencing creative expression worldwide. In sculpture, they pioneered the realistic representation of the human form, evolving from the stylised rigidity of the Archaic period to the naturalism and dynamism of the Classical era. Greek pottery served both utilitarian and artistic purposes, with intricately painted scenes depicting mythology, daily life and cultural values. The development of the architectural orders established enduring principles of proportion, harmony and ornamentation. In literature, the epic poems of Homer laid the foundation for Western literary tradition, while the

works of poets like Sappho and Pindar explored personal emotions and celebrated athletic victories. Greek drama, while emerging from religious festivals, grappled with profound philosophical questions and served as a form of social commentary, with the innovations of playwrights, such as Aeschylus, Sophocles, Euripides and Aristophanes, having a lasting impact on theatre. The Greeks' artistic achievements are deeply intertwined with other aspects of their culture, from religion and mythology to philosophy and intellectual pursuits, reflecting their understanding of the cosmos and the human experience. Their enduring legacy in art, literature and aesthetics is a testament to the universal resonance of their ideas and the timeless power of human creativity.

3.

Religion and Mythology

Ancient Greek religion and mythology form a complex and fascinating system of beliefs, stories, and practices that profoundly shaped the culture and worldview of one of history's most influential civilisations. This chapter explores the intricate pantheon of gods and goddesses, the inspiring tales of heroes, and the rituals and festivals that united communities in shared devotion and celebration. From the powerful Olympians presiding over the celestial realm to the mortal heroes whose exploits blurred the lines between human and divine. Greek mythology provides unique insites into the values, fears, and aspirations of an ancient society.

The Olympian Pantheon

The gods and goddesses of ancient Greece have captivated imaginations for millennia. These powerful divine beings were integral to the culture and collective consciousness of ancient Greek civilisation, providing primordial explanations for natural phenomena and human experiences

while also serving as figures of inspiration in art, drama, poetry and beyond.

Central to the Greek mythological canon were the twelve Olympian deities, who resided on Mount Olympus and who represented core facets of the natural and human worlds. The most prominent Olympians were Zeus, the king of the gods; Hera, the queen and goddess of marriage; Poseidon, god of the sea; Demeter, goddess of agriculture and the seasons; Athena, goddess of wisdom and strategic warfare; Apollo, god of archery, music and prophecy; Artemis, goddess of the hunt and wilderness; Ares, the war god; Aphrodite, goddess of love and beauty; Hephaestus, god of fire and metalworking; Hermes, messenger god and guide to the underworld; and either Hestia, goddess of the hearth, or Dionysus, god of wine and ecstasy. The inclusion of Hestia or Dionysus in a given version appears to be related to local mythic variants and the preferences of individual authors or artists. The idea that Hestia willingly gave up her place for Dionysus was invented by mythographer and story-teller Robert Graves. Beyond the Olympian circle were a myriad of other gods, goddesses, spirits and demons that populated the Greek cosmological landscape across the realms of earth, skies and the underworld.

Revered as king and father of gods and mortals, Zeus was the embodiment of authority, in maintaining

cosmic order amidst chaos, and of justice. There are countless tales of his sexual exploits – both in his own form and that of various animals – alongside stories of his leadership in waging wars against giants, titans and monsters that threatened the Olympian regime. Worship to Zeus centred on grand temples and sites of pilgrimage, like the renowned Temple of Zeus at Olympia or his oracle at Dodona in northern Greece. As the divine figure who arbitrated between order and disorder, the Greeks' immense respect for and worship of Zeus reveals a cultural desire for stability and prosperity amidst life's uncertainty.

As Zeus's consort and queen, Hera represented ideals of matrimony, feminine power and the sanctity of domestic life. But she was also renowned for her changing moods and notorious jealousy-fuelled bouts of vengeance, especially against her husband's various lovers and offspring. The majesty and importance of her cult can be seen through the magnificent size and opulence of her temple in the city of Argos, as well as one of the earliest monumental stone temples in Poseidonia (modern Paestum in southern Italy). Hera's multi-dimensional role as a nurturing wife and dangerous threat seems to mirror the complex social views on wifely duty alongside feminine influence and fury in ancient Greece. Perhaps her most famous act of vengeance was

against Zeus's son Heracles, whom she cursed at birth, and which ultimately led to his Twelve Labours – a series of 'impossible' tasks demanded of the hero by King Euystheus of Mycenae, whom he served for twelve years following the murder of his wife, Megara, and their children. They included killing the Nemean lion, capturing the Erymanthian Boar, stealing three golden apples from the Hesperides, and bringing Hades's three-headed dog Cerberus back from the Underworld. It was the completion of these tasks that ultimately led to Herakels's apotheosis.

Ruling the oceans and storms with his mighty trident, Poseidon embodied the primal, volatile nature of the sea and its crucial role in Greek seafaring society. Myths tell of his quick temper, his ability to summon earthquakes and floods, and his disputes with other gods over domains and mortals. Most famously was his challenge to Athena over control of Athens which resulted in the god striking the ground with his trident and causing a salt-water well to appear, though the goddess ultimately won the challenge by creating an olive tree, a gift that would give the Athenians oil and fruit and high-quality wood. Coastal cities like Corinth dedicated grand maritime temples and festivals to solicit Poseidon's favour and calm seas for vital trade routes. The fearful respect for Poseidon's ocean domain speaks to Greek dependence on seafaring

for commerce and community ties amidst the sea's ever-present danger.

As a goddess of wisdom, skill and strategic warfare, Athena embodied an intellect and martial poise prized in Greek society. Myths tell of the fully armoured Athena springing from Zeus's head, highlighting her ingenuity and battle-readiness as she aided epic heroes like Odysseus. The majestic Parthenon temple atop Athens's Acropolis celebrates the city's revered patroness and protector. Reverence towards Athena signifies Greek respect for level-headed cunning that tempers aggression; this is well demonstrated by her invention of the war chariot and the tactics she employed during the Trojan War, including the famous 'Trojan Horse'. Tales of her patronage offer explainable models to follow to overcome adversity through balanced wit and strength, most notably in the cases of Achilles in Homer's *The Iliad* and Odysseus in *The Odyssey*.

As the goddess who controlled the fertility of croplands and the changing of seasons, Demeter was worshipped as a life-giving yet sorrowful mother goddess figure. Each year when her daughter, Persephone, left the mortal world to return to her husband in the underworld, Demeter's grief brought barrenness as she withdrew her gifts. Their joyous reunion marked the return of the earth's bounty, with Demeter facilitating the growth of crops

and flourishing of livestock. Initiation into the secretive Eleusinian Mysteries (on which see later) promised adherents better fortunes in life and after it through Demeter's good graces. The cyclical myth of loss and return seems tied to a cultural desire for consoling explanations and a sense of control over nature's seasons of unpredictable harvest yields and starvation.

The virgin goddess Artemis embodied the untouched wilderness and the moon with her retinue of nymph followers. Sworn to perpetual maidenhood and independence, she fiercely punished threats to her chastity or integrity of the natural environment she roamed through hunting. Myths tell of her righteous rage against those who disrespected her vows, such as Orion, Sipriotes and Actaeon, whom she ruthlessly kills. Ancient Ephesus constructed one of the Seven Wonders of the Ancient World, an opulent Artemisian temple, to solicit her guardianship. The reverence for Artemis's fierce purity and autonomy perhaps reflects a cultural appreciation for feminine power outside male-dominated realms like marriage.

The handsome archer-god Apollo embodied the illumination provided by intellectual and artistic pursuits. As god of poetic arts, truth, healing, plague, purification and prophecy, his oracles, such as at Delphi, uttered mysterious predictions. The bright and dark duality in his myths matches the cultural desire for enlightened

order but also an acceptance that destiny and death remained mysteries beyond complete human comprehension or control. Apollo has several passionate yet doomed romances, including with the youth Hyacinthus whom he accidentally kills with a flying discus. He is less successful with maidens – unsuccessfully pursuing Daphne who turns herself into a laurel tree to escape him.

As goddess of love, beauty and carnal desire, Aphrodite enchanted mortals and immortals with her dazzling allure, though often casting violence through the passions she evoked. Hesiod tells us she was born from the sea foam that formed around the severed genitals of the sky god Ouranos (grandfather of Zeus and his siblings), after they were cast into the sea by his son Kronos, but Homer reports her as the daughter of Zeus and the nymph Dione. Tales tell of her dramatic marriage to the blacksmith god Hephaestus and her brazen affair with the war god Ares, including the pair being caught in a fine metal net and put on public display to the other Olympians. Aphrodite's influence reveals Greek recognition of Eros's intoxicating power and destructive potential through its temporary madness.

The forge and craft god Hephaestus personified ingenious artisanship combined with fiery danger. Though disabled and initially spurned by his mother, Hera, as misshapen, Hephaestus's skill at metalworking earned

him a restored place on Olympus with a palace work-shop even grander than his fellow gods. His mechanical automatons in myths underscore Greek respect for tech-nological innovation. Yet his near loss of divine status and vengeful traps against cheating wife Aphrodite or mother Hera, who threw him from Mount Olympus, warn about unchecked threats from inventions that may turn against even their makers.

The war god Ares embodied the sheer violence and horror of battle contrasted by the strategy and cunningness of Athena and the cultural necessity of war in Greece. He was shunned by most Greek cities for his chaotic and violent nature, with few temples and sanctuaries dedicated to his worship. His major myths mainly serve to be bested by others – by the craftiness of Odysseus, who routed his armies and left him yelling unheroically or confined in a jar for nearly a year by two giants aided by Hermes. Tales warn of Ares's unchecked bloodlust compared to Athenian strategic prowess, but Spartan veneration shows Greek acknowledgement that war's devastation remained essential for victory and spoils, especially widespread in the tumultuous era of city-state conflicts.

As messenger and herald, guide of souls, god of path-ways, commerce, trickery and thieves, Hermes was a well-travelled deity underscoring mobility and communi-cation essential to Greek livelihood across sea and land.

Tales illustrated his versatility and wit, whether settling disputes among immortals or aiding heroes' quests with his cap of invisibility against foes like the hundred-eyed giant Argus, whom he slew to rescue Zeus's lover Io. Worship of quick-footed Hermes betrays cultural reliance on the agile conveyance of goods, news and ideas across rugged homeland terrain and risky oceans for trade and prosperity.

Dionysus, the so-called 'twice born', was the son of Zeus and the mortal Semele. While still pregnant, Semele was killed by a trick of Hera's and the unborn Dionysus was sewn into Zeus's thigh to be born 'again' when he was fully formed. He embodied the Greek desire for liberation and ecstasy but also chaos from losing all inhibition. His cult promised primal catharsis both directly through festivals that included wine drinking and indirectly through the theatre. Dionysian worship encouraged temporary subversive release through intoxication and euphoria. But the story of Euripides's *Bacchae* gives a stark warning of Dionysus's destructive power. Pentheus, King of Thebes, banned Dionysus's worship in the city, so the god drives the Theban women to madness, leading to the violent death of the King at the hands of his mother. Tales like these warn about the excess of breaching social order, but also about the necessity of catharsis.

Heroic Ideals

In addition to tales of powerful Olympian deities, ancient Greek mythology wove elaborate stories about mortal heroes blessed with superhuman abilities yet still vulnerable to very human struggles. These epic heroes starred in literary sagas, dramas and visual arts as figures who embodied the pinnacle of courage, strength and cunning alongside profound personal flaws and trauma.

Perhaps the most celebrated Greek hero, Heracles (or Hercules in Roman versions of the myth), was famed for his iconic feats of superstrength, known as the Twelve Labours. His trials read like hero quests including slaying beasts like the Nemean Lion, Lernaean Hydra and Stymphalian Birds to stealing prized objects from faraway lands for the arrogant King Eurystheus of Tiryns. Each spectacular deed represented virtues like bravery and perseverance against long odds that any Greek could aspire to in facing life's everyday trials and battles.

But Heracles won such wide admiration not just through his unparalleled success – he was, after all, fathered by Zeus and gifted with godlike might. Instead, the Heraclean saga resonated profoundly with Greek audiences thanks to its blending of glorious victories with catastrophic downfalls tied directly to internal struggles. Interspersed among his grand quests are deep personal losses usually triggered by the goddess Hera's vengeance

and her sworn mission to destroy her philandering husband Zeus's half-mortal son. A scene of the epic hero strangling deadly serpents sent by Hera to kill him in the cradle illustrated extraordinary power forged through early childhood trauma, foreshadowing repeated patterns haunting him all the way to his peaks of prosperity.

The most gut-wrenching morality tale comes when Hera's divinely induced madness on to him causes Heracles to massacre his first wife Megara and their children before he snaps back to sanity and suicidal horror at his involuntary crimes. His subsequent performance of the Twelve Labours under arrogant King Eurystheus doubles as both a redemption quest and punitive enslavement. Such stories warned that even with superhuman strength, one needed humility in the face of the gods. This was reinforced by the sculptural programme at Olympia, where the story of Heracles was emblazoned on the Temple of Zeus.

Ultimately, Heracles met his end not because of Hera's wrath, but by his own unchecked passion. His second wife, Deianeira, fearful of losing him, accidentally poisoned him with a 'love potion' that actually contained the poisoned blood of the centaur Nessus, whom Heracles had killed. As his body burned in agony, Heracles built his own funeral pyre on Mount Oeta and ascended or *apotheosised* to full immortal godhood upon the flames consuming his mortal form. The scene encapsulates

profound Greek heroic ideals through images of will-power over pain, death through dignity, and transcend-ence reaped as a reward for extraordinary virtue strained through mortal flaws.

Ancient Greek Rituals and Festivals

Beyond mere celebrations, the rituals and festivals threading through ancient Greek society composed of a vibrant communal tapestry reinforcing cultural cohesion and pious connectivity. These sacred events illuminated the Greeks' profound reverence for their pantheon while also spotlighting how collectively shared worship unified the *polis* (city-state) and people.

Greek religion intrinsically bonded community and divine communion across overlapping groups from the smallest community, the family, to the Panhellenic world. The vocabulary of religion reveals specific concepts under-pinning rituals binding citizens together in religious spec-tacle. Altars, sacrificial offerings and libations (liquid offerings) allowed devotees to communicate with gods by feeding and honouring them through ritual. Music, dance and songs glorified the gods during gatherings. Athletic contests like the Olympic Games pushed human limits while paying homage to mighty Zeus through competitive feats. The transformation of such vocabulary into our modern lexicon hints at the perpetual cultural

and religious power of the ancient Greeks. Altars still anchor sacred spaces; libations carry on through toasts, hymns swell within houses of worship and international athletics originate from these ancient devotional games. More than maintaining traditions, this resonance signifies the perpetual need for unifying touchpoints between people and the divine unknown.

This communal worship is vividly entwined through Greece's yearly rituals based around harvests or myth cycles renewing nature's yield. Major civic festivals like Athens's Panathenaia saw the deity's statue paraded through streets in divine processions, with people coming into the city from all over the region or – in some cases – the whole Greek world: participants or observers united in exultation. Accounts describe the electric communal energy felt during the week-long Great Panathenaic festivals that occurred every four years. Vivid details envision Athenians converging upon the Acropolis, bearing rich offerings while hymns fill the air as incense smoke rises in honour of the olive-bearing city patroness Athena. It is an awe-inspiring image.

The significance of such festivals is greater than merely honouring the gods involved. Participants from across the socio-economic spectrum could come together and bond over shared experiences and desires for their city's prosperity. Like the collective tension released through

theatre, watching epic tragedies of loss and ruin, celebrating cyclic renewal together ritually uplifted *polis* populations worn by life's persistent troubles. Far beyond a simple diversion, these festivals built social bonds, channelled awe of the divine and anchored civic identity through unification. Shared rituals engender a communal spirit, bringing people together to confront life's uncertainty. In honouring the gods who oversaw all human domains, the Greeks communally affirmed nature's cycles that persistently give and take away no matter one's status. In this way, feelings of anxiety and uncertainty could be quelled by taking control of the collective relationship between the people and the gods.

The Trojan War

One of the most famous and influential stories from ancient Greek mythology is the Trojan War. This epic conflict, which was said to have taken place around the twelfth or thirteenth centuries BCE, has been immortalised in literature, art and popular culture for millennia. According to myth, the war began when Paris, a Trojan prince, abducted Helen, the stunningly beautiful wife of Menelaus, king of Sparta. This act of betrayal enraged Menelaus and his brother Agamemnon, king of Mycenae. They gathered a massive army of Greeks and set sail for Troy, determined to retrieve Helen and exact revenge on the Trojans.

The ensuing war lasted for ten years, with neither side able to gain a decisive advantage. The Greeks, led by legendary heroes like Achilles, Ajax and Odysseus, laid siege to the city of Troy but were unable to breach its formidable walls – reportedly built by Apollo and Poseidon. The Trojans, meanwhile, fought valiantly under the leadership of their greatest warrior, Hector, son of King Priam. Both sides suffered heavy losses as the war dragged on. Hector was slain in single combat by Achilles, who then desecrated his corpse by dragging it behind his chariot. Achilles, the mightiest of the Greek warriors, was in turn shot by Paris with an arrow to his heel, his only weakness.

In the end, the Greeks prevailed through cunning rather than force. Odysseus, assisted by Athena, devised a plan to build a giant wooden horse and leave it outside the gates of Troy as a supposed offering to the gods. The Trojans, believing the horse to be a sacred object, brought it inside their city walls. Unbeknownst to them, the horse was filled with Greek soldiers who emerged at night and opened the gates, allowing their comrades to pour in and sack the city.

The fall of Troy marked the end of the war, but for many of the combatants, the journey was far from over. Odysseus, in particular, faced a long and arduous voyage home, beset by monsters, witches and the wrath of the

gods. His epic journey, recounted in Homer's *The Odyssey*, has become one of the most enduring tales of literature.

The story of the Trojan War, with its larger-than-life heroes, dramatic battles and timeless themes of love, honour and destiny, has captivated audiences for centuries. It has inspired countless works of art, from ancient pottery and frescoes to modern films and novels. The phrases 'Trojan Horse' and 'Achilles heel' have become part of our common lexicon, a testament to the enduring power of these mythic figures. Yet for all its grandeur and romance, the Trojan War also serves as a cautionary tale about the destructive power of pride, jealousy and the thirst for glory. In the end, both the Greeks and the Trojans paid a terrible price for their hubris, and the once-great city of Troy was reduced to ashes. It is a reminder that even the greatest of human achievements can be undone by the flaws and passions that lurk within us all.

Oracles and Omens

The ancient Greeks were devout believers that the gods sent signs and visions to unveil the mysteries of fate. This conviction drove them to ardently embrace the practice of divination – interpreting messages from the deities to guide critical decisions. Prominent oracles, the most famous being the Oracle of Delphi, held immense power

as conduits between mortal and divine realms. According to legend, Zeus himself decreed Delphi the 'navel' or *omphalos* of the earth. Nestled amid the olive groves and rocky cliffs of Mount Parnassus, this sanctuary was considered a mythic epicentre where gods and humans could convene.

The Pythia, a high priestess who served as the living voice of Apollo at the Oracle of Delphi, underwent elaborate preparations before delivering prophecies. After ritual baths and offerings, she would ingest laurel leaves and breathe vapours rising from cracks within the earth. These supposedly induced an ecstatic trance that opened her mind to visions of the future. Seated upon her tripod, speaking in puzzling verse, the Pythia dispensed advice that could decide the fates of kingdoms. When the Spartan Leonidas faced impending war with Persia, the Pythia foretold that either a king must die or Sparta would fall. Leonidas took this as a sign to sacrifice himself at Thermopylae to delay the Persian onslaught.

Yet the Pythia's often cryptic words still required human interpretation, which was fallible. Croesus, the fabulously wealthy king of Lydia, left Delphi assured that attacking Cyrus the Great would topple a mighty empire. To his ruin, he realised too late that the empire the Pythia had foreseen falling was his own, and he was

bested by Cyrus in battle. Still, whatever the outcome, Greeks embraced the Pythia's divine wisdom as essential to navigating their destiny's uncertain currents. We can envision the devout processions making the daunting trek up Mount Parnassus to Apollo's temple, bearing rich offerings to earn the god's favour. They believed the Pythia spoke for the immortal gods themselves. Her words could determine the fate of families, generals and even nations.

Clearly, the longing to pierce the veil of the future was profound in ancient Greece. Though Delphi was pre-eminent, oracle-hosting temples spread across the Grecian world. Towns like Dodona and Claros also boasted prophetic priestesses conveying divine knowledge on private and public affairs. The Greeks integrated prophecy thoroughly into all aspects of existence because they fervently believed the gods shaped human destiny while revealing glimpses of its course. This conviction that fate may be divined and influenced reflects an eternal anxiety over our inability to control what lies ahead. In many ways, the crumbled ruins of Delphi continue to echo that elemental human obsession with unmasking destiny that still endures. Perhaps we still seek signs and omens to steady our steps along uncertain paths, hoping to wrest insight from the unknowable future.

The Eleusinian Mysteries

The Greeks held no rite more sacred and intriguing than the Eleusinian Mysteries – a secretive initiation-based cult (theoretically) open to any person who spoke Greek. It honoured Demeter and her daughter, Persephone (under the pseudonym Kore, which means 'maiden' or 'girl') and focused on Demeter's search for Kore after her abduction by Hades. Performed each year at Eleusis, near Athens, these dramatic rituals promised terrestrial blessings in life and beyond the grave for initiates known as *mystai*. According to mythology, mostly narrated through the *Homeric Hymn to Demeter*, Hades, Lord of the Dead, erupted from the earth to abduct the maiden goddess while she picked flowers, taking her as queen of his realm. Her distraught mother, Demeter, blighted the land with famine until Zeus intervened. But because Persephone ate pomegranate seeds while in the underworld, she had to return underground for several months each year, and her emergence into light signalled spring.

At the Mysteries' secret climax inside the Telesterion hall, initiates may have consumed a 'kykeon', a drink made of water, barley and honey, which some scholars have contended contained barley infected with the psychoactive fungus, ergot. During this time, priests theatrically re-enacted Persephone's descent and return. It is supposed that by tapping into this death-rebirth

cycle, initiates were spiritually transformed, overcoming mortality fears through temporary union with the divine. Utmost secrecy was mandatory – betrayal being punishable by death – so little is actually known of these meticulously guarded rituals. But ancient authorities agree that initiation stirred profound catharses and changed lives by unlocking the soul's immortality.

For two millennia, the Mysteries attracted worshippers to their mystical promise of seasonal, agricultural fecundity and happiness in the afterlife though a strong relationship formed with the goddesses. Their endurance testifies that the story of Persephone, perpetually dying and resurrected, profoundly resonated in the Greek psyche. And it still captivates us today.

Ancient Greek religion and mythology were integral to the culture and collective consciousness of the civilisation, providing explanations for natural phenomena and human experiences while serving as a source of inspiration in art, drama and poetry. Central to the Greek mythological canon were the twelve Olympian deities, each representing core facets of the natural and human worlds, with Zeus reigning as the king of the gods and numerous other divine beings, spirits and demons populating the cosmological landscape. Greek mythology also featured epic heroes like Heracles, embodying the pinnacle of human virtues alongside profound flaws and struggles.

Rituals, festivals, oracles and mystery cults were vital in reinforcing cultural cohesion, religious devotion and the pursuit of divine guidance. The enduring influence of Greek religion and mythology is evident in the countless references and allusions found in literature, art and popular culture throughout history, with epic tales like the Trojan War and the complex pantheon of gods and goddesses continuing to captivate audiences and inspire creators across the centuries, leaving an indelible mark on the Western cultural tradition.

4.

Cultural Exchange, Influence and Colonisation

From its earliest stages, ancient Greek civilisation exhibited an expansive and adventurous spirit that led it to extensively interact with, influence and colonise cultures across the Mediterranean world and beyond. This outward focus fostered an era of cultural exchange and intervention between Greece and neighbouring civilisations like Egypt, Phoenicia and Persia, resulting in the incorporation of different ideas, art forms and technologies into Greek society and vice versa. The extensive colonisation spearheaded by the Greek city-states further expanded the spread of Greek language, customs, religion, architectural styles and artistic traditions across regions spanning from the Black Sea to the western Mediterranean.

While often characterised as a one-sided endeavour, Greek colonisation and cultural expansion exposed Greece itself to the beliefs, aesthetic principles and knowledge systems of other societies. The intermingling of Greek settlers and local populations created unique cultural

blends where Greek, Egyptian, Near Eastern and Etruscan traditions amalgamated into distinctive hybrid forms. This cultural diffusion fundamentally transformed not only the numerous territories and peoples 'Hellenised' (that is, 'made more Greek') by the Greeks but also the outlook and identity of Greek civilisation itself as it absorbed external ideas. This cosmopolitan dynamism would culminate in the late Hellenistic era, with the Greek world increasingly coming under the sway of Rome. The complex cultural interplay between Greece and Rome would lay the civilisational foundations of Europe, echoing through subsequent millennia.

Interaction with the Near East

From its earliest phases of development, ancient Greeks actively engaged with the Near Eastern civilisations, a region that comprises parts of modern West Asia, the Balkans, the Middle East and North Africa. This contact consolidated a robust multi-directional cultural exchange that permeated Greek society. As early as the seventh century BCE, the Greeks of Ionia adapted the gold and silver coinage of the nearby Lydian kingdom and the Phoenician abjad, a writing system that contains only consonants, which they modified by adding vowels to better suit the Greek language. This adaptation laid the foundation for the development

of the Greek alphabet and, consequently, the Western alphabetic tradition.

In literature, Near Eastern narratives powerfully captured the Greek imagination, infiltrating their own literary canons. The myth of a world-ending flood destroying humanity except for a lone survivor or family resonated across West Asia in *The Epic of Gilgamesh* before the Greeks created their own version featuring the king, Deucalion (and most famously known through the version of Noah and his ark in the Hebrew Bible). There is also the story of the priestess Io's passage across the known world in the guise of a brilliant white cow, preserved in Aeschylus's *Prometheus Bound*, bears a striking parallel to earlier Sumerian stories. There are traces of earlier work from Canaanite, Hittite and Phoenician theogony filtered into the literature of Greece, underscoring the interconnectivity of oral traditions of storytelling between these various Eastern Mediterranean cultures.

However, it was with the vast Persian (Achaemenid) Empire that the most complex cultural cross-influence occurred. Following Cyrus the Great's conquest of the Greek cities of the Ionian coast (modern Turkey) in the mid-sixth century, years of conflict between Greece and Persia simmered, culminating in two main waves of the Greco-Persian Wars of the early fifth century. Although we often think of these as 'Greece' versus Persia, the Greek

side was more complex than this suggests. It was made up of a variety of city-states in a loose coalition, while some 'Greek' poleis or allies were on the Persian side (including, notably, Macedonia, from which Alexander the Great would later emerge). Despite these conflicts, there were still vibrant channels of cultural exchange between Greeks and Persians. Greek artists and architects incorporated Near Eastern ornamental motifs into their work, while Greek philosophy, mathematics and advances in medicine stimulated the work of Near Eastern intellectuals. These open channels of cross-cultural exchange existed before the war, both between the 'mainland' Greeks and 'mainland' Near Eastern populations. There was continued trade and cross-cultural influence in places where 'Greek' cities and Persian cities were located near one another (including on the Ionian coast).

Greek Colonisation Across the Mediterranean

Greek colonisation efforts commenced in the eighth century BCE, stemming from various social, political and economic triggers. An expanding population and scarcity of arable land spurred the need to secure provisions for the citizens of numerous city-states. The Greeks established two main types of colonies: *emporia*, which served as trade outposts, and *apoikia*, which were larger, more permanent settlements.

Emporia, like Naucratis in Egypt or Olbia in modern Ukraine, linked Greek commerce to wider Afro-Eurasian networks. These trade outposts were staffed by merchants and specialised craftsmen who catered to both Greek and other tastes, becoming vital conduits for transmitting outside ideas into Greece itself. Other *emporia* were established by Greeks tempted by the mineral wealth and fertility of sparsely settled areas in Italy, France, Libya and around the Black Sea. Many of these cities, like Cyrene in North Africa and Massilia in southern Gaul, evolved into prosperous cities in their own right – sometimes outstripping their metropolis. As the impulse to 'spread out' progressed through the Archaic, Classical and Hellenistic periods, strategic military considerations increasingly spurred colonisation to project state power abroad. By the time of Alexander the Great's conquests, Greek colonies studded trade routes from Mediterranean Spain to Afghanistan, catalysing vibrant East–West connections across Eurasia.

Spanning over two centuries, ancient Greek colonisation seeded urban settlements across four continents, establishing several major regional zones of Hellenic culture overseas. In 'Magna Graecia' (literally, 'Greater Greece', encompassing southern Italy and Sicily), Greek migrants established colonies along the coasts, introducing the architectural styles, pottery and religious cults from

mainland Greece. Cities like Taras (modern Taranto), Sybaris (in modern Calabria), and Akragas (modern Agrigento) soon emerged as leading Mediterranean powers, rivalling those in Greece itself. Even further west, in modern Marseille, the Greek trading colony of Massilia catalysed the diffusion of Greek language and culture among neighbouring Celtic tribes, linking Gaul to the Mediterranean economy. Over centuries, the Massiliotes nurtured a remarkable synthesis of Hellenic and Celtic culture that impressed both Greek and Roman observers for its vitality.

North of the Black Sea, trading posts established by Ionian and Aeolian Greeks quickly transformed into wealthy trade ports linking southern Europe to Scythian lands in Central Asia. The vibrant Bosporan Kingdom in the Crimea and Taman Peninsula preserved its Greek linguistic and religious customs even while nominally subordinate to Pontus and Rome at various stages. In the Nile Delta, the port of Naucratis hosted merchants and mercenaries from multiple Greek city-states and functioned as the gateway for trade with Egypt. Nurturing an expat community of Greek artisans and scribes, it also became the springboard for the Greek intellectual fascination with pharaonic culture, culminating in the syncretic reign of the Hellenistic Ptolemaic Dynasty over Egypt itself.

The remarkable breadth of Greek colonial expansion left lasting contours on the cultural geography of Europe and the Mediterranean while also exposing Greek society to external influences. Indigenous peoples interacting with these settlements often voluntarily embraced elements of Greek culture, language and ethnic identity. Artistic cross-pollination flourished in colonies through creative appropriations of indigenous styles, motifs and techniques, which then fed back into mainland Greek art. Therefore, the colonies did not just radiate Greek culture outward uniformly but also channelled external concepts back into the Greek world view through circular currents.

Hellenistic Expansion

The conquests of Macedonian crown prince Alexander the Great in the late fourth century BCE, who died in 323 BCE, ushered in the Hellenistic period; an era marked by the unprecedented expansion of Greek culture and influence across vast territories in North Africa and the Near East (what we now call the Middle East), all the way across to India. Alexander's campaigns stretched from the Balkans to the Indus Valley, bringing Greek culture into further contact with the civilisations of Persia, Egypt, Bactria and India – cultures were now not just influencing one another but being forcibly mixed as a political tool. In the aftermath of Alexander's death, his empire was

divided among his generals, leading to the establishment of the Hellenistic kingdoms, most notably the Ptolemaic dynasty in Egypt, the Seleucid Empire in Persia and Mesopotamia, and the Antigonid dynasty in Macedon. These became what we know as the Hellenistic Kingdoms, which brought together the indigenous cultures of these areas and Greek culture.

Under these kingdoms, Greek culture underwent a remarkable transformation, absorbing and synthesising elements from the conquered territories. The city of Alexandria in Egypt (Plutarch tells us Alexander named at least seventy cities after himself, but more realistic estimates put that number at between twelve and twenty), founded by Alexander and further developed by the Ptolemies, became the intellectual and cultural capital of the Hellenistic world. The Library of Alexandria and the adjacent *Mouseion* (a research institution) attracted scholars from across the Mediterranean, fostering advancements in science, mathematics, literature and philosophy.

The Hellenistic period saw the establishment of new Greek cities and settlements across the conquered territories, further expanding the reach of Greek culture. Cities like Antioch in Syria, Seleucia in Mesopotamia, and Ai-Khanoum in Bactria became important centres of Greek learning and culture, even as they incorporated elements from local traditions. Greek became the lingua

franca of the Hellenistic world, facilitating increasing levels of Hellenisation – a term which comes from the Greek verb *hellenizo* meaning something like 'I adopt Greek ways or language'. Previously, multilingualism across the Persian Empire had facilitated political and cultural exchange, but this was streamlined under the Greek rulers of the Hellenistic kingdom, and if one wanted a career in politics, then they must learn Greek. Local languages were still spoken at lower levels of society, but in the courts and palatial centres of the Hellenistic world, Greek was necessary. Greek religious beliefs and practices also intermingled with local traditions, resulting in the emergence of new syncretic cults, such as the cult of Serapis in Egypt. Hellenistic art and architecture also reflected this cultural fusion, with the incorporation of Near Eastern motifs and styles into Greek artistic forms.

The Hellenistic period witnessed significant advancements in science, mathematics and philosophy. The Stoics and Epicureans developed new schools of thought that would have a lasting impact on 'Western' philosophy. There was a further flourishing of Greek art and architecture, with the emergence of new artistic styles and the construction of monumental buildings, such as the Pergamon Altar and the Colossus of Rhodes. Libraries, of which the most famous is the lost Library of Alexandria, were built across the Hellenistic world.

This enabled scholars to access materials that previously may have been inaccessible and laid the foundation for groundbreaking contributions to geometry, physics, geography and the natural sciences. One such scholar was Archimedes of Syracuse, a mathematician and inventor whose groundbreaking contributions to geometry included obtaining the area of a circle, the surface area and volume of a sphere, and the area under a parabola using the method of exhaustion. He is also credited with laying the foundations of hydrostatics and statics, including the discovery of the principles of buoyancy and leverage, and the invention of numerous ingenious mechanical devices, such as the Archimedes screw for raising water, compound pulleys, and defensive war machines like the claw of Archimedes used during the Siege of Syracuse.

The legacy of the Hellenistic period expansion of Greek culture had far-reaching consequences for the development of Western civilisation. The synthesis of Greek and Near Eastern cultural elements laid the foundation for the emergence of a distinct Hellenistic identity, which would shape the intellectual, artistic and political landscape of the Mediterranean world for centuries to come. The transmission of Greek ideas and knowledge through the Hellenistic kingdoms also facilitated the preservation and dissemination of key Greek texts, including

the works of Homer (collated by the first known chief librarian of Alexandria, Zenodotos of Ephesus), which would later play a crucial role in the Renaissance and the development of modern Western thought. Poet and scholar Callimachus wrote an extensive catalogue of all known authors and their works, and although that work is itself lost, enough references remain for us to know the basic structure and surmise how the library itself may have been organised.

Ancient Greek civilisation exhibited an expansive and adventurous spirit that led to extensive inter-action, influence and colonisation of cultures across the Mediterranean world and beyond, fostering an era of cultural exchange between Greece and neighbouring civilisations like Egypt, Phoenicia and Persia. This outward focus resulted in the incorporation of foreign ideas, art forms and technologies into Greek society and vice versa, while also exposing Greece to the beliefs, aesthetic principles and knowledge systems of other soci-eties. The extensive colonisation efforts, spanning from the Black Sea to the western Mediterranean, further expanded the reach of the Greek language, customs, religion, architectural styles and artistic traditions. The intermingling of Greek settlers and local populations created unique cultural blends, transforming both the territories and peoples 'Hellenised' by the Greeks and

the outlook and identity of Greek civilisation itself. The conquests of Alexander the Great in the late fourth century BCE ushered in the Hellenistic period, marked by an unprecedented expansion of Greek culture and influence across vast territories in North Africa, the Near East and as far as India, leading to a remarkable synthesis of Greek and Near Eastern cultural elements. This cosmopolitan dynamism, culminating in the rich cultural interplay between Greece and Rome, would lay the civilisational foundations of Europe and echo through subsequent millennia, demonstrating that the enduring global imprint of Greek culture was not an isolated miracle but rather the consequence of centuries of vibrant foreign interaction and exchange.

5.

Social Hierarchies, Enslavement, Non-Citizens

Ancient Greek society was a bricolage of social and civic hierarchies. Citizenship stood as a cornerstone institution, giving its holders a set of rights, privileges and responsibilities that set them apart from the rest of the populace. It was within this context that various types of governance were codified, including democracy in Athens and elsewhere and various forms of aristocracy, monarchy and diarchy (the latter notably in Sparta, where there were two concurrent royal families). Citizenship was, however, only afforded to certain people, and this was juxtaposed against the social position of women, children, resident foreigners and enslaved people.

Citizens – Athens and Sparta

Citizenship in the ancient Greek world was a concept imbued with profound significance. It served as a marker of social status, political enfranchisement and cultural identity. The rights and responsibilities of citizenship

varied across the tapestry of Greek city-states, each *polis* establishing its own unique pattern of civic engagement and participation. In all cases, however, citizenship was restricted to adult men who were native to the city; in some cases, there were wealth or property requirements and those who fell outside those were stripped of their citizenship. Two of the most prominent and contrasting examples, and those for which we have the most evidence, are Athens and Sparta.

In Athens, the so-called 'birthplace of democracy', citizenship was given to free adult males who could trace their lineage back to Athenian ancestors. These privileged individuals held the right to participate in the *Ekklesia*, the assembly where matters of state were deliberated and decided. Athenian citizens could serve on juries and were eligible for public office, including prestigious roles, such as *archons* ('magistrates') or *strategoi* ('generals'), but they were also expected to take up arms in defence of Athens, pay taxes, perform liturgies and contribute to the common good of the *polis*. In contrast, Spartan citizenship was characterised by martial ethics and rigid social hierarchy. Male Spartan citizens, called Spartiates, underwent a rigorous military training regime, the *agoge*, which forged them into warriors par excellence. They were expected to dedicate their lives to the service of the state, placing duty and loyalty above all else. Spartan

citizens formed the *homoioi*, the 'equals' who ruled over the helot population, a wholly enslaved community tied to the land. These two extremes of Athenian and Spartan citizenship differed in accordance with their respective societal values. Athenian men were expected to engage in public life, participating in the political, judicial and cultural institutions of the *polis*. They could be found debating in the *agora*, attending symposia or enjoying the theatre. Spartan men, on the other hand, were consumed by military duties and the pursuit of physical excellence, their days spent in training and their nights in communal mess halls.

The exclusivity of citizenship in ancient Greece cannot be overstated. Only a small fraction of the population could claim this privileged status; estimates range between around 10 and 20 per cent of the population, with women, slaves and foreigners being denied the rights and responsibilities of full civic participation. This exclusion served to reinforce the social hierarchies and power dynamics that underpinned Greek society. Despite these inequalities, the concept of citizenship in ancient Greece laid the foundations for the development of democratic principles and practices that would echo through the ages. The idea that individuals could have a say in the governance of their community, that they could shape the laws and policies that affected their lives, was a revolutionary one.

The legacy of ancient Greek citizenship, with all its flaws and limitations, continues to inspire and inform our understanding of what it means to be a member of a political community.

Metics

Metics, or resident foreigners, occupied a unique and often overlooked position in Athenian society; although we know that there were resident foreigners in other *poleis* we have little evidence for them. These foreign residents, coming from diverse corners of the Mediterranean world, formed a distinct class within the social hierarchy of Athens. However, there was also economic and social stratification within the group. They were free individuals who had chosen to make their home in Athens for a variety of reasons. Some were born elsewhere and came to Athens for economic opportunity or education and cultural enrichment. Others, perhaps a majority, were brought to Greece following their enslavement and were later granted freedom. They occupied the same economic and social hierarchies as citizens, but without political rights. Regardless of their background, metics were united by their status as outsiders, forever marked by their foreign birth or prior servitude. Despite their non-citizen status, metics played a vital role in the economic and social life of Athens.

However, the rights and privileges of metics were limited in comparison to those enjoyed by citizens. They could not own land, participate in the political process, or marry Athenian citizens. They were required to register with the authorities and secure a citizen sponsor, a *prostates*, who would vouch for their character and conduct. In legal matters, they were subject to the same laws as citizens but had to rely on their *prostates* to represent them in court. Despite these constraints, metics found ways to make their mark on Athens. Many were skilled artisans, merchants or craftsmen, their expertise and entrepreneurial spirit contributing to the growth and prosperity of their adopted cities. They were a driving force behind the city's thriving commerce, plying their trades in the bustling *agora* and contributing to the tax base through the *metoikion*, a special tax levied on foreign residents. Some rose to prominence through their intellectual pursuits, like the philosopher Aristotle, who was born in Stagira but spent much of his life teaching in Athens. Others achieved renown through their artistic talents, like the sculptor Phidias, whose masterful works adorned the Parthenon. Metics also made significant contributions to the defence of their adopted cities, serving as oarsmen in the Athenian navy or as hoplites (heavily armed soldiers) in the army.

The presence of resident foreigners in Athens served as a testament to its cosmopolitan nature, a reminder that

the boundaries of community were not impermeable. The metic experience, with its blend of opportunity and limitation, highlights the complex interplay of status, identity and belonging that characterised ancient Athens. The skills, knowledge and perspectives brought by metics enriched the societies they inhabited, challenging the notion that citizenship was the sole measure of worth or value. The legacy of the metic class serves as a reminder that diversity and inclusivity have long been drivers of human progress and innovation.

Women

Women and children in ancient Greece occupied a complex and often subordinate position in the social hierarchy. Their roles, rights and responsibilities were largely defined by the patriarchal structures that under-pinned Greek society, which placed men at the centre of public life and relegated women and children to the domestic sphere. Women's lives were circumscribed by a set of social norms and expectations that emphasised their primary roles as wives, mothers and household managers. Women were largely excluded from the public realm, barred from participating in politics, commerce and other areas of civic life. Instead, they were expected to remain within the confines of the *oikos*, the house-hold, where they managed the day-to-day affairs of

the family and oversaw the work of slaves and servants. Women were given an opportunity to provide value to the *polis* through their participation in religion, including women's only festivals like the Thesmophoria, in honour of Demeter.

Marriage was a pivotal moment in the lives of Greek women, marking the transition from a father's household to a husband's. Marriages were usually arranged by a girl's father, with little regard for the preferences or desires of the individuals involved. Girls would have been married at between fifteen and eighteen years old, while men were probably around thirty. Once married, women were expected to bear children, particularly male heirs, and to provide a stable and nurturing environment for their families. But the experiences of women in ancient Greece were not monolithic. Spartan women reportedly enjoyed a greater degree of freedom and autonomy than their counterparts in other city-states. They received a formal education, participated in athletic training and could own and inherit property. In contrast, Athenian women were more strictly confined to the domestic sphere, their movements and interactions with men outside the family closely monitored and regulated.

The experience of metic women in Athens differed significantly from that of citizen women. While still subordinate to men legally and socially, and with the

same requirements for sponsorship as men, metic women were not subject to the same strict social controls and expectations as the wives and daughters of citizens. They had more freedom of movement in public spaces, and were not confined to the domestic sphere in the same way. Many metic women worked outside the home, including as traders, nurses, midwives and in other occupations. This gave them an economic role and public visibility that was rare among citizen women, particularly elite citizen women, as Athenian women from lower socio-economic classes would also have worked outside the home. Some of the most influential and famous women in Athens were metics, including Aspasia, the long-time companion of Pericles. Aspasia played an active role in the intellectual life of the city, conversing with politicians and philosophers in her home – something an elite citizen woman would not have been permitted to do. Metic women were also strongly associated with the group of *hetairai* – sex workers who provided entertainment and companionship as highly educated courtesans. While citizen men frequented *hetairai*, citizen women were expected to remain faithful to their husbands and avoid male company outside their families. The greater freedoms of metic women were thus a function of their exclusion from the citizen body and the norms that governed it. These contrasts should not be overstated,

though – metic women still operated within a patri-archal society and lacked the legal protections and status accorded to citizens, and there is still a strong socio-economic factor regarding those who are able to pursue a more public lifestyle.

Children

Children's lives were also shaped by the prevailing gender norms and hierarchies. Male children were (future) citizens, soldiers and leaders. They received a formal education, often under the guidance of male tutors or *paidagogos*, which prepared them for their future roles in public life. Female children were educated in the proper running of the household, including in textile manufac-turing. As children grew older, their paths diverged based on their gender and social status. Boys from wealthy fami-lies might continue their education, studying rhetoric, philosophy and other subjects that would prepare them for leadership roles. Girls, meanwhile, were often married at a younger age, their education focused on domestic skills, such as weaving, cooking and child-rearing.

The status of children in Athens, where we have the fullest evidence, is complex and evolves over time. In the early stages of democracy, in the Archaic period, citizenship was tied to membership of a phratry, a kin-ship group, rather than being clearly defined. As political

decision-making became more democratic, a clearer definition of 'citizenship' emerged. Between the reforms of Solon and Cleisthenes, phratry membership probably conferred citizenship, though the precise qualifications in this period remain obscure. After Cleisthenes's reforms, deme (a kind of municipal neighbourhood) membership became the key to citizenship, with a citizen father being sufficient to secure a child's status. It is unclear whether maternal citizenship alone could confer this right on a child, as it did in some other *poleis*. The citizenship law of Pericles in 451 BCE marked a crucial turning point, requiring both parents to be Athenian citizens in order for a child to gain membership of the citizen body. In enacting this, Pericles disenfranchised his own children with his non-Athenian, metic partner Aspasia. This exclusive standard, despite some fluctuations in enforcement, remained the basic principle going forward. To assume their position as citizens, young Athenian males had to be formally enrolled in their deme (municipalities or neighbourhoods) upon reaching the age of eighteen, at which point their legitimacy and qualifications (including the status of their parents) were scrutinised. So Athenian citizenship came to be restricted to an even narrower segment of the population, with only the children of two citizen parents being eligible for this privileged status.

Enslaved People

There was a more sombre reality persisting underneath the upper layers of Greek social hierarchies – the widespread and firmly established practice of slavery. Enslaved persons, divested of their self-determination and relegated to the status of mere property, constituted a substantial segment of the populace in the Greek world. In Athens, estimates suggest that enslaved people numbered between 80,000 and 100,000 people, around 25 per cent of the total population. Despite their vital role in sustaining the economic and social structures of ancient Greek civilisation, the contributions and experiences of these individuals have often been relegated to the margins of historical discourse.

People became enslaved for a multitude of reasons. Some were born into enslavement, inheriting the status of their parents. Others were prisoners of war, their destinies shaped by the outcomes of military conflicts, which they may or may not have fought in. Many such people came into Greece through the slave trade rather than direct enslavement, though these people were often enslaved by similar means. As a result, the enslaved population encompassed a wide mix of individuals from various ethnic, cultural and geographic origins. The most numerous were from Thrace, Anatolia and Syria, and often kept or were given names that indicated their

ethnic origins. They were deployed in a diverse array of roles, ranging from household and agricultural workers to miners and craftsmen. Some of the enslaved, especially those possessing specialised skills or intellectual aptitudes, occupied more privileged positions, serving as educators, scribes or administrators.

Regardless of their specific roles or status, the enslaved were systematically deprived of fundamental rights and liberties. They lacked legal recognition, were barred from owning property, and could not enter into legally binding contracts, although some were able to accumulate limited personal possessions, including clothing. They were constantly vulnerable to physical violence, sexual abuse and exploitation, and various forms of mistreatment at the hands of their owners. The conditions endured by slaves varied considerably, depending on the dispositions and proclivities of their owners, but the inherent power asymmetry that characterised the enslaver-enslaved dynamic precluded the possibility of genuine benevolence or empathy, even if there were some relationships that were closer and kinder than others.

Despite the oppressive nature of slavery in ancient Greece, some enslaved individuals were able to secure their freedom through manumission. This process of granting freedom to an enslaved person was not uncommon, particularly in Athens. The enslaved could

be manumitted by their owners as a reward for steadfast loyalty, through self-purchase using accumulated funds, in acknowledgement of exceptional deeds or circumstances, or (frequently) freedom could be granted in the will of an owner. Upon attaining their freedom, these individuals, known as 'freedmen' or 'freedwomen', often assimilated into the *metic* population, joining the ranks of free non-citizens within the *polis*. But this was not without significant obstacles. Although technically liberated, they continued to bear the stigma of their former status, and frequently encountered suspicion, prejudice and social marginalisation. Their background was an indelible mark that could never be fully erased. Like metics they also required sponsorship from a citizen, who was often a member of the family who had formally enslaved them, meaning this freedom may also be contingent upon working in previously held positions. Freedmen were compelled to navigate the intricate social hierarchies of the Greek world, endeavouring to carve out a niche for themselves in a society that prioritised citizenship and lineage above all else.

The ubiquity of enslavement in ancient Greece is underscored by the fact that even in the idealised, hypothetical societies conjured up by philosophers and playwrights, the institution remains present. In Plato's *The Republic*, in Aristotle's vision of the ideal city, and

in the whimsical Cloud Cuckoo Land of Aristophanes's *The Birds*, an enslaved population is taken for granted as an integral part of the social order. The idea of a society entirely devoid of slavery was relegated to the mythical Golden Age, a utopian realm where all needs were met without human toil. This reveals the deeply entrenched nature of slavery in the Greek mindset, a reality so pervasive that even the most radical thinkers and dreamers could not conceive of its absence.

Ancient Greek society was characterised by a complex system of social hierarchies and civic distinctions, with citizenship serving as a cornerstone institution that granted certain rights, privileges and responsibilities to a select group of individuals. The concept of citizenship varied across the Greek city-states, with Athens and Sparta representing two contrasting models, but was generally restricted to adult men who were native to the city, excluding women, children, resident foreigners (metics) and enslaved people. Metics, though free, were subject to legal and social constraints, while women were largely relegated to the domestic sphere, their roles and experiences shaped by prevailing gender norms and expectations. Children's lives were also influenced by these hierarchies, with boys receiving education to prepare them for future roles as citizens and girls being trained in domestic duties. Beneath these layers of society, enslaved

individuals, deprived of basic rights and subjected to various forms of exploitation and mistreatment, played a vital role in sustaining the economic and social structures of ancient Greece, their experiences and contributions often marginalised in historical discourse. The pervasiveness of slavery in Greek society, even in idealised philosophical and literary visions, underscores its deep entrenchment in the Greek mindset. The social fabric of ancient Greece, with its complex interplay of status, privilege and power, offers a fascinating lens through which to examine the ways in which societies structure themselves and allocate resources, shedding light on the enduring struggles for recognition, equality and dignity that unite the human experience across time and culture.

6.

Environment and Agriculture

The ancient Greeks maintained an intricate relationship with the natural landscape, using the diverse environments and temperate climate that surrounded them to develop thriving agricultural practices and resource management systems. The mountains, islands, forests and seas that defined Greece served as both bounty and barrier – providing essential natural resources while also limiting urban sprawl. Over centuries of civilisation, the Greeks learnt to cultivate olive groves on steep hillsides, build advanced aqueducts to siphon mountain run-off, establish sustainable fishing practices in the Aegean and protect timber reserves for fuel and shipbuilding.

Yet the Greeks also faced environmental challenges as early industrial activities took their toll. Mines stripped silver from the hills while also releasing toxic pollution, overgrazing and logging led to soil erosion, and natural disasters like droughts and earthquakes could devastate farming communities. The ancient Greeks, therefore, enacted an early system of environmental conservation,

with forest reserves, rotating fallow fields, marshland protections and religious sanctions against overexploiting nature's gifts. This intricate balance between utilising natural resources for survival and economic growth while also seeking sustainability and conservation defined Greece's agricultural and environmental practices for centuries. All Greek poleis were subsistence economies, and Greeks lived a life of what Hesiod calls *autarkeai*, or 'self-sufficiency'. The vast majority – up to 80 per cent – of the population in Greece were farmers of some kind, either owner-operator farmers, employed on farms, or working on farms as enslaved labourers. The reliance on the land and agriculture facilitated the worship of divinities like Demeter and Dionysus who governed aspects of this worked landscape and were propitiated in order to secure successful harvests.

Hesiod and Didactic Poetry

Hesiod's *Works and Days* is a seminal pastoral poem that provides insight into ancient Greek agriculture and rural life. As a farmer himself living in Boeotia in the eighth century BCE, Hesiod draws directly from his agricultural experiences, advising his brother Perses on when to sow crops, how to manage oxen teams, and general truths on farming household management. Interspersed with this practical farming wisdom, Hesiod integrates allegorical

tales that illustrate moral truths aligned with agriculture – the need for hard work, avoiding idleness and unjust gain. The poem moves fluidly between literal advice on grain, grape and olive cultivation to metaphorical advice on leading a virtuous, diligent life. *Works and Days* exemplifies how wisdom around agriculture and pastoral life served as the foundation for broader moral instruction for the ancient Greeks. Its themes and illustrations capture the essence of early pastoral life while presaging the future evolution of the pastoral genre in Greek and Roman literature. Whether recommending when to gather acorns or when to marry, Hesiod's poem reveals how thoroughly entangled agriculture and morality were in the Greek world view.

Greek Geography and Climate

The diverse geography of Greece encompassed a wide array of environments and microclimates – from the arid, rocky hills of Attica to the lush flood plains of Thessaly and the sun-drenched islands of the Aegean. The mountain ranges that criss-crossed the Greek landscape provided rain-shadow effects, with one slope lush and rainy while the other remained dry. Cool upland forests contrasted with intensely cultivated lowland plains ideal for growing grapes, olives and grain. The climate also shifted from north to south – northern areas like

Macedonia dealt with harsher winters and bigger seasonal swings than the southern Peloponnese. Island climates, meanwhile, reflected surrounding sea temperatures, leading to mild, humid winters and hot summers. These dramatic geographic and climatic distinctions created markedly different agricultural systems and crops across Greek regions while also limiting development in more extreme upland areas and requiring creative irrigation and water management practices in drier lowland plains. Understanding these distinct microclimates and terrains is key to analysing the diverse environmental relationships and agricultural practices found across ancient Greece.

The diverse climates and terrains of Greece directly impacted agricultural production, trade patterns and urban development. The lush flood plains of Thessaly and Macedonia produced immense grain surpluses that could be traded across the Aegean, which was necessary to accommodate the growing populations of cities like Athens and Corinth. Meanwhile, the hillsides of Attica and Crete were ideal for olives and grapes – speciality crops that became pillars of Greek commerce and cuisine. Port cities emerged across the coasts to funnel these agricultural goods abroad and, in turn, to import commodities that were less common or not found in Greece, like timber, minerals and exotic foods back home. However, harsh upland areas of Greece with poor soil, extreme winters

and limited rainfall could not support such development – many remained isolated rural outposts focused on small-scale subsistence farming. The mountains and seas that defined Greek geography also hemmed in settlement growth, pushing urban centres to develop into densely populated areas reliant on ingenious infrastructure solutions to bridge gaps and supply resources. Understanding how these environments affected agriculture, trade and urban growth is critical for analysing the uneven development and regional diversity seen across ancient Greece.

While the temperate Mediterranean climate enabled Greek agriculture and development, environmental limitations still posed periodic challenges. Unreliable rainfall, disease brought by insects and other pests, or inappropriate land management were all common causes for famine and food crisis in dependent urban centres, though famines may also be caused by political or military campaigns, such as purposeful destruction as a result of warfare or profiteering. Food crisis is much more common than true famine, and the fact that for much of the relatively stable fifth century, Athens had fewer food vulnerabilities than in the fourth century under Macedonian hegemony suggests these were more likely politically or militarily motivated. Other data suggests that crops failed regularly enough that segmentation of farms was common, where a single farmer would have

fields in several different microclimates (for instance, in the plains and in the mountains) to 'hedge' their yield.

Deforestation to make room for farmland and fuel mineral smelting stripped hillsides bare, leading to erosion and loss of timber reserves. The giant silver mine at Laurion generated immense wealth for Athens and was the major source of funding for the establishment of the Athenian navy, but also produced toxic pollution that contaminated nearby soil and water. This was the cause of large numbers of deaths from such pollution, including carbon monoxide poisoning. Historiographer Xenophon calls Laurion an unhealthy place, but as the majority of deaths were of enslaved hard labourers, this was also considered a normal part of the business of mining. Earthquakes, volcanic eruptions and tsunamis also wreaked sporadic havoc – the volcanic explosion on Santorini dealt a blow to the advanced Minoan civilisation centred there. Managing these environmental threats through infrastructure investments, resource management protections and religion-enforced restraint became key to ensuring longevity. Yet the Greeks also pragmatically accepted periodic disasters and climate variability as inevitable checks on widespread prosperity. This relative tolerance fuelled a cycle of crisis and recovery, destruction and renewal that underpinned the whole ancient Greek relationship with nature.

Agricultural Practices

The mountains and valleys of Greece fostered a diverse agricultural bounty that sustains Mediterranean cuisine to this day. Olive groves coated hillsides while grape-vines twined through the lowlands. Grain fields rippled across the broad northern plains of Boeotia, Thessaly and Macedonia. Combined with vegetables, herbs and livestock like sheep, goats and cattle, these crops provided daily sustenance. The Greeks innovated tools like the scratch plough, millstones for processing grain and advanced presses for wine and olive oil to increase yields. Sophisticated techniques like crop rotation, terracing on slopes and complex drainage and irrigation networks expanded arable land. While small family farms and estates tilled the majority of Greek fields, monumental urban expansion also relied on the labour of enslaved populations, including chattel slaves and, in some regions, state-owned enslaved groups (such as the *helots* in Sparta, and the *woikeus* in Gortyn). This combination of advanced farming knowledge and mixed exploitative labour systems produced the agricultural bounty that made Classical Greek civilisation possible.

While the alluvial plains and terraced hillsides of ancient Greece fostered advanced intensive agriculture, many upland and marginal areas relied on the seasonal movement of livestock between highland and lowland

pastures. Sheep and goats grazed mountain meadows in the summer and then were led to coastal plains for winter fodder. This mobile animal husbandry adapted well to poor soil, thin vegetation and extreme winters that limited cultivated crops. However, the lifestyle and social patterns of these shepherding mountain communities stood in stark contrast with settled lowland farmers. This meant smaller, isolated village settlements rather than concentrated urban centres in agricultural regions. It also promoted legal and property arrangements like common grazing lands that differed radically from privately owned farms. And the culture of upland shepherds – from clothing, music and art to marriage customs – developed distinct traditions from their farming neighbours in the southern Greek lowlands and islands. Managing both the crops of intensive agriculture and the flocks and herds of mobile pastoralism was essential for the Greeks to exploit their landscape fully.

Greek agriculture witnessed significant innovations and increasing diversification of crops and techniques over the centuries. Complex irrigation networks like stone-lined cisterns and tunnels that tapped underground aquifers expanded arable land, as did slope terracing. Agricultural manuals, mostly lost but detailed by Roman writers like Varro, gave traditional knowledge of planting cycles, soil amendments and orchard care

that improved crop health and resilience. As specialised commodity agriculture for cash crops like wine and olive oil expanded, family smallholdings increasingly focused on high-value fruits, vegetables, herbs, nuts and dyes for urban markets. This specialisation was facilitated by improved trade networks; the conquests of Alexander the Great opened up trade routes to the East, importing exotic new crops like citrus fruits and cotton for Greek farmers to experiment with. This steady diffusion of agricultural knowledge, techniques and crop varieties over time enabled ever-rising production and diversification in Greek farming, although at the cost of increased labour demands and some heightened environmental strain from expanded water use and deforestation.

Resource Management
In addition to agriculture, the ancient Greeks relied heavily on fishing, mining, quarrying, hunting and lumber harvesting to provide key resources. The seas, forests and mineral deposits of Greece supplied vital food, materials and trade commodities. Commercial fisheries shipped preserved salted fish, allowing for this key protein source to be transported over longer distances and stored for extended periods. Mines at Laurion and Thasos tapped precious metals like silver and gold. Quarries cut high-quality marble, limestone and clay for

construction and artisanal goods. Vast forests provided lumber for fuel and shipbuilding, as well as game animals like deer. These extractive industries employed specialised labour forces, and many endured harsh and dangerous working conditions. Greeks located near these deposits grew exceptionally wealthy – the economies of Athens and Corinth boomed thanks to nearby silver, clay and fishing grounds. However, overexploitation of these resources posed challenges, especially from deforestation, overfishing and mine pollution, necessitating sustainability efforts.

The ancient Greeks developed community-based resource management systems to govern shared assets like pastures, forests and water sources sustainably. Local assemblies and religious sanctuaries set seasonal restrictions on grazing, logging and hunting in communal woodlands and high mountain meadows. Sacred groves were carefully demarcated, consecrated and protected by rules that prohibited felling trees, breaking branches, setting fires and other disturbances. Irrigation cooperatives allocated water from rivers and reservoirs to farmers based on community ties, needs and customs. These bottom-up rules and norms reduced overexploitation, although elite landowners still often dominated decision-making. During times of drought or disaster, communities cooperated to repair shared water infrastructure like

aqueducts and cisterns quickly. However, tensions still emerged between users – upstream towns could starve downstream neighbours of water while transhumant herders saw winter grazing access as a right. Finding equitable and sustainable balances for managing these collective goods remained an imperfect but essential process in a landscape where few resources existed in endless abundance for long.

The ancient Greeks confronted several environmental limitations that threatened agricultural productivity and economic growth. Deforestation from lumber harvesting and fuel demands led to serious concerns over the depletion of timber reserves by the fourth century BCE. The importance of timber supply and the effects of deforestation and erosion were evident to ancient Greek observers, who often lamented them. It became difficult to find timber suitable for shipbuilding, good forests retreated to the mountains, and sources of valuable wood were exhausted. Extended droughts, earthquakes, floods and other disasters challenged sustainability, prompting writers like Plato and Aristotle to advance early environmental thought, while politicians like Pericles ushered through resource protections and promoted colonial efforts to relieve population and land pressures at home. Yet a true consciousness of environmental limitations emerged only fitfully. The Greeks exploited their surroundings to

drive an economic boom that in turn funded cultural and political pinnacles – restraint was often an afterthought or temporary reaction to crisis, rather than a consistent ethos across society.

The ancient Greeks maintained a complex relationship with their natural environment, utilising the diverse landscapes and temperate climate to develop thriving agricultural practices and resource management systems. Over centuries, they learnt to cultivate crops like olives and grapes on hillsides, build advanced irrigation networks, establish sustainable fishing practices and protect timber reserves. However, they also faced environmental challenges, such as deforestation, soil erosion and pollution from early industrial activities like mining. In response, the Greeks developed community-based resource management systems, setting seasonal restrictions on grazing, logging and hunting, and protecting sacred groves. They also grappled with the limitations of their environment, as droughts, earthquakes and other disasters threatened agricultural productivity and economic growth. Writers like Hesiod, Plato and Aristotle provided insights into the moral and philosophical dimensions of agriculture and the environment, while politicians implemented resource protections and promoted colonial efforts to relieve population and land pressures. Ultimately, the ancient Greeks' relationship

with their environment reflected a dynamic interplay of dependence and limitation, innovation and destruction, as they sought to balance the utilisation of natural resources for economic and cultural advancement with the need for sustainability and conservation.

7.

Law and Justice in Ancient Greece

The ancient Greeks developed sophisticated legal frameworks and judicial processes across the independent city-states that emerged in the first millennium BCE. While regional variations existed due to political, social and cultural differences, common ideals of justice, civic duty and collective welfare shaped these legal institutions. The development of law and justice in ancient Greece provides valuable insights into the development of legal institutions, philosophical debates about justice, and the role of law in shaping Greek society and politics. From the earliest written laws in the seventh century BCE to the sophisticated courts of Classical Athens, the Greeks experimented with various models for administering justice and resolving disputes through transparent collective processes. While there were local variations due to political, social and cultural differences, shared ideals of justice, civic duty and collective welfare shaped these legal institutions.

In Athens, the *Heliaia*, a people's court, heard legal disputes and public charges tried before panels of six

thousand juror-citizens. Defendants and accusers delivered speeches arguing their position, calling upon witnesses when necessary, in a public adversarial system that placed a premium on fancy rhetorical persuasion over simple statements of the case. Other city-states had similar processes; Sparta's state-administered system focused on preserving strength and social order. In most city-states, social and civic customs carried weight, yet legal codes evolved to cover issues from trade and property to personal rights and duties. While some legal codes, such as that of Athenian lawgiver Draco in the late seventh century BCE, were considered excessively harsh, others, like Solon's reforms of the sixth century BCE, sought balance. Concepts of justice focused on fairness, precedent, proportionality and the public good. Tensions sometimes arose between state law and personal or religious ethics, as in the legend of Antigone defiantly burying her brother against royal decree. In Sophocles' famous adaptation of the myth, Antigone's personal conviction and loyalty to divine law compel her to ignore King Creon's edict, resulting in her tragic fate. The play raises enduring questions about the boundaries of state authority and the individual's right or duty to resist unjust laws, suggesting that an overly rigid application of human law can lead to injustice and social disruption if it fails to account for fundamental moral and religious norms.

While Athenian democracy has informed the Western legal tradition, we find diverse models across Greece. The multifaceted codes, courts and assemblies reveal commitments to civic participation, deliberation and equitable judgement that remain hallmarks of just governance today. Regional variations remind us that reasonable people may disagree on the particulars of justice while upholding its spirit.

Athenian Legal System

The Athenian courts were groundbreaking institutions that placed justice directly in the hands of citizen bodies. Evolving over decades and centuries, the laws, officials and courts of Classical Athens defined an adversarial legal process where prosecution and defence presented evidence and pleas before large panels of juror-judges. In the seventh century BCE – with composition starting around 621 BCE – Draco, the Athenian lawmaker, began codifying laws in Athens. All that remains of this code are the laws around homicide, which made blood feuds obsolete by establishing set consequences for killings based on intent and circumstances. Such codification set key precedents, as did the political and economic reforms of leading politicians, such as Solon and Cleisthenes, including establishing the *Heliaia*, the 'supreme court' of Athens, which also acted as an appeals court.

By the fifth century BCE, the archons ('rulers') directed most charges through the *dikastai* – six thousand jurors who served by lot for one year (the title relates to the ancient Greek word for justice – *dike*). Defendants and accusers delivered speeches arguing their positions, assisted by advocates when necessary. Witnesses could be questioned and jurors voted by secret ballot by placing either a white or black pebble into the appropriate jar to determine guilt or innocence, with a majority determining guilt or innocence. If equal votes were cast, the case was awarded to the defendant. In some cases, the *dikastai* could vote for censure, a form of public reprimand, in addition to the usual verdicts of guilt or black pebble in the appropriate jar. There were other legal institutions in Athens, including the Areopagus, which retained jurisdiction over cases of homicide, assault and immorality. This comprised men who had previously served as archons and may have originally been a 'council of elders'. The nine senior archons, who presided over the Areopagus, also conducted the pre-trial arbitration to determine which court would hear which cases. Lower magistrates oversaw local *demes* courts handling minor disputes. Specialised courts like the Forty judged theft, while admirals heard maritime cases.

In this way, Athenian law practised democratic principles with checks against hasty judgement. The jurors

represented Athenian society across class divisions sworn to decide solely based on evidence presented to them. Penalties ran from property fines to exile or death. In 399 BCE, the philosopher Socrates was convicted and sentenced to death for impiety and corrupting youth – charges officially tied to his unorthodox ideas, though his defiant attitude likely angered the court.

While Athenian courts advanced democratic ideals, only free citizen men served as legal actors. Metics ('resident foreigners') and women had limited rights to bring cases. Enslaved individuals could not initiate legal action and could only serve as witnesses under torture. Such exclusions underline the privileging of certain voices within supposedly egalitarian institutions. Still, in granting average citizens direct authority over legal judgements, Athenian law furnished an enduring template for participatory justice. The system was designed to enshrine fairness and collective wisdom within an institutional framework where, theoretically, all citizens, and those non-citizens who had a citizen to bring a case for them, could obtain just and fair treatment.

While non-citizens, such as metics and women, had some access to the Athenian legal system, their participation was limited compared to that of male citizens. Metics, who were free resident foreigners, had the right to bring cases in court, but they needed their *prostates*

(patron) to represent them. This requirement made it more difficult for metics to initiate legal action, as they were dependent on the willingness of the patron to support their case. Women, whether Athenians or not, were even more restricted in their legal rights. They could not bring cases directly and needed a male relative or guardian – their *kyrios* ('lord') – to represent them in court. In some instances, such as in cases of divorce or inheritance disputes, women might be directly involved as parties to a case, but they still could not speak for themselves in court. Despite these limitations, there is evidence that both metics and women did make use of the Athenian legal system when necessary. The speeches of Attic orators, such as Lysias and Demosthenes, include examples of cases involving metics and women. One notable example is the case of Neaira, a metic woman accused of falsely claiming Athenian citizenship, which is preserved in a speech attributed to Demosthenes. These cases were, though, less common than those involving adult male citizens, and the limited legal autonomy of metics and women underscores the fact that, despite its democratic ideals, the Athenian legal system privileged the participation of a specific group of residents. The concept of equality before the law was not fully inclusive in practice. Nevertheless, the Athenian system still represented a significant step towards participatory justice

compared to some other ancient societies – Greek and otherwise – as it granted a relatively large segment of the population direct access to, and influence over, the legal process.

The Athenian legal process relied on citizen participation across several pivotal roles: prosecutor, defendant, witnesses and juror-judges. Understanding how they interacted within the courts provides insights into Athenian concepts of justice. In most cases, the prosecution and defence were carried out by the litigants themselves. Such private cases were called *dikai*. Litigants could seek assistance from speechwriters known as *logographoi*, who would compose speeches for them to deliver in court. These speechwriters were not assigned randomly but were hired by those who could afford this service, potentially leading to disparities in the quality of representation based on wealth and social status. In some cases, they could hire a *synergoros* (supportive speaker) to deliver professionally prepared arguments. In public cases, *graphai*, an official magistrate, would establish the charge, but the prosecution was carried out by volunteer citizens acting as 'prosecutors' (*kategoroi*) on the state's behalf. This was all predicated on the fact that the legal system was entirely a structure of civil law rather than criminal prosecution. Legal charges were initiated by summoning the accused to court on a designated day. In either type of case, both

sides had the opportunity to deliver their case, and then present witnesses to corroborate it. Witnesses could be interrogated and challenged. In one case describing a violent brawl, witnesses provided conflicting accounts of the fight, leaving jurors to judge truthfulness. The final judgement rested with a large jury of typically 201 to 501 citizens, known as *dikastai*, who were selected by lot from a pool of six thousand eligible citizens over the age of thirty.

The mass citizen juries represented the collective judgement of Athens. Taking an oath to decide solely on the evidence, jurors voted after hearing both sides. In close decisions, the jurors' verdict could be swayed by the persuasiveness and emotional impact of the speeches rather than just the facts of the case. The famous trial of Socrates illustrates this dynamic: the philosopher's defiant – even arrogant – clash with his accusers, likely alienating jurors accustomed to displays of humility, even as his commitment to truth over self-preservation embodied a higher ideal of justice. The case highlights the tension in Athenian courts between procedural fairness and individual conscience.

Athenian courts heard a broad spectrum of both private disputes and public offences. Homicide cases, originally tried under Dracon's seventh century BCE code, went before the Areopagus Council. In these trials,

the defendant bore the burden of proving their actions were accidental or carried out in self-defence. Solon's reforms in the early sixth century allowed assault and battery to be prosecuted in court rather than avenged through personal retribution. This change aimed to replace cycles of violence with public adjudication, with penalties scaled to the severity of the crime.

Property disputes were common, involving contested inheritance rights, dowry claims and boundary lines. Plaintiffs and defendants argued their understanding of entitlements or proper demarcations. Jurors weighed contradictory claims based on testimony, laws and intuitive ideas of fairness. Financial matters like loans, investments and maritime insurance came under court view, especially when one side alleged a breach of contract. An example of this kind of litigation is offered in the speech *Against Zenothemis*, one of Demosthenes's legal orations – the plaintiff Demon accuses the defendant Zenothemis of falsely claiming ownership of a cargo of grain. According to Demon, he had entered into an agreement to transport the grain and was owed payment for freight and storage costs. But when the ship carrying the grain was forced to dock at Athens due to a storm, Zenothemis allegedly conspired to claim the grain for himself, arguing that he had lent the money for its purchase. Demon brings a suit to recover his expenses and expose the fraudulent

attempt to seize merchandise under the pretence of a loan agreement.

Family law comprised another major area of litigation. Relatives might sue over maintenance of widowed or orphaned relatives, marital abuses or inheritance claims. Existing laws and customs provided a framework, but courts had leeway to interpret and apply them based on case specifics. Even homicide could fall under this purview. The mythical trial of Orestes, dramatised in Aeschylus's *Eumenides*, exemplifies the complex interplay of family obligations, personal vengeance and legal judgement that characterised such cases. Orestes's murder of his mother Clytemnestra is portrayed as both righteous fulfilment of filial duty and of a pollution requiring expiation and judicial punishment. The Erinyes, ancient goddesses of retribution, pursue Orestes for his matricide, while Apollo and Athena argue for the supremacy of judicial and civic order. The Athenian court's ultimate acquittal of Orestes, decided by Athena's tie-breaking vote, suggests a shift from the archaic system of blood vengeance to a new model of public justice.

Across this spectrum of issues, the Athenian courts gave citizens an arena to contest legal rights and interests openly. Its processes combined individual argumentation, witness proofs and communal judgement in striving

towards public justice. The breadth of matters under formal jurisdiction reveals the Athenians' concerted effort to manage private and public affairs through an egalitarian adjudication process combining plaintiff claims, rhetorical argumentation, witness testimony and the judgement of the jury. While imperfect, it was an innovative experiment in balancing private autonomy with civic order and equity. Greek conceptions of justice thus sought to reconcile tensions between institutional order and individual conscience, ancestral custom and reformed law. Justice functioned as both a stabilising social force and a contested ideal, inspiring ongoing refinements of existing codes towards standards of greater fairness and collective wisdom.

Against Neaira

The legal speech 'Against Neaira', attributed to Demosthenes but likely written by Apollodorus, provides a compelling case study of how Athenian prosecutors could strategically argue a case involving complex issues of citizenship, gender norms and religious propriety. In this particular suit, the prosecutor Theomnestus, with Apollodorus as his co-speaker, brought a *graphē xenias* (public action against an alien) against a woman named Neaira.

Neaira, originally from Corinth, was a former enslaved sex worker who had become the long-time partner of the

citizen Stephanus while living in Athens as a *metic*. The prosecution's argument hinged on proving that Neaira had illegally claimed citizen rights through a de facto marriage to Stephanus. Apollodorus, delivering the bulk of the speech, painted a vivid portrait of Neaira's history in the sex trade to demonstrate her foreign status. He presented witnesses to this effect and recounted her failed unions to citizen men, which produced allegedly illegitimate citizen children like her daughter Phano. To further prove Neaira's guilt in conspiring to pass Phano off as a legitimate citizen, Apollodorus challenged Stephanus to hand over one of Neaira's enslaved attendants for interrogation under torture, believing it would confirm Phano's true parentage. The invocation of such methods and the emphasis on lineage reveal the extremely high stakes of citizenship claims hinging on an individual's natal origins and purity. Stephanus refused, likely fearing the potential testimony.

Beyond seeking a conviction against Neaira, Apollodorus aimed to shame Stephanus for enabling a former sex worker to usurp the citizen-wife's role and privileges. The prosecutor played heavily on gender and class biases, linking sexual impurity with the contamination of citizen-only religious rites in which Neaira's daughter had sacrilegiously participated. The speech thus appealed to the citizen jurors' anxieties about metics

transgressing social hierarchies and undermining the *polis*' moral and sacred foundations.

Though we do not know the trial's outcome, Apollodorus clearly aimed to inspire outrage at this perceived affront to the sanctity of citizen-only marriage, reproduction and cult. His attack on Neaira's character and Stephanus's flagrant violation of Athenian law reflects the primary rhetorical strategy of rousing jurors' desire to protect citizen privilege against the incursions of sexually suspect foreign women. A guilty verdict would have reaffirmed Athens' commitment to strictly policing the boundaries of female virtue, citizen purity and participation in the *polis*' social and religious life, with severe consequences for those who transgressed them.

Spartan and Other Systems

While Athens provides the most prominent example, ancient Greek city-states developed diverse legal institutions reflecting their distinct characters. Comparisons reveal shared commitments and noteworthy divergences. In militaristic Sparta, the laws of Lycurgus established a regimented system aimed at preserving hierarchy and martial prowess. A council of elders (called the *Gerousia*) drafted decrees for an assembly of Spartan males to accept or reject, and a series of customary oral laws complemented the so-called 'Great Rhetra' – the Spartan written

constitution. Five annually elected ephors enforced regulations and settled disputes swiftly. Jury courts played a lesser role than in Athens, with magistrates delivering most rulings. Unlike the citizen-centred approach of the *dikasteria*, Spartan oligarchs restricted widespread adjudication powers. For both Athens and Sparta, upholding law correlated with civic virtue. Athenian litigiousness reflected prizing individual liberty and democratic principles. Spartan discipline leveraged law to reinforce strict hierarchy and unwavering obedience.

Other systems blended collective and authoritative elements. In Gortyn, Crete, a fifth century BCE code inscribed on a wall in the city's *agora* presented rules publicly while investing judicial powers in magistrates. In Syracuse, courts of different sizes heard various case types under Dionysius I's fourth century BCE rule. The common thread uniting ancient Greek legal conceptions was aiming for impartiality. Adapting law to local circumstances, most systems sought to establish neutral processes for settling disputes. Whether archaic blood feuds or Classical oratory, justice hinged on replacing singular force with collective deliberation.

Beyond city-states, inter-city agreements provided legal recourse when citizens of one place incurred losses or injuries elsewhere. For example, 'amphictyonies' which were religious associations of neighbouring states that

were formed to protect and administer sacred sites and their festivals. The earliest and most famous was the Delphic Amphictyony, which managed the temple of Apollo at Delphi and the Pythian Games. Member states sent representatives to biannual meetings where, in addition to regulating sacred matters, they arbitrated disputes between members and could impose sanctions on offenders. Amphictyonies thus played a quasi-legal role in settling regional conflicts and enforcing shared norms, even if they had a primarily religious mandate. They represent one way Greek city-states sought to establish interstate codes of conduct and dispute resolution mechanisms, even while resisting full political unification. Amphictyonies helped enshrine Panhellenic ideals of justice and restraint in warfare under divine sanction, though they also became entangled in power politics, as evident in the series of 'Sacred Wars' fought over control of Delphi. Overall, these leagues exemplify how ancient Greeks attempted to reconcile autonomous local government with the need for impartial authorities to regulate interstate affairs – a key tension in the development of ancient international law.

The ancient Greeks developed sophisticated legal frameworks and judicial processes across their independent city-states, with common ideals of justice, civic duty and collective welfare shaping these institutions

despite regional variations. In Athens, the *Heliaia*, a people's court, epitomised a participatory system where citizens served as jurors, hearing cases presented by litigants in a public forum. This concept of citizens actively engaging in the administration of justice was a cornerstone of Athenian democracy, though limited to free male citizens. Other city-states, like Sparta, had more authoritarian systems focused on maintaining social order and hierarchy. The Greeks grappled with complex legal issues and philosophical questions surrounding justice, as reflected in the works of thinkers like Draco, Solon and Aristotle, as well as in the mythical tales of figures like Orestes and Antigone. These intellectual and cultural traditions laid the groundwork for the development of Western jurisprudence, with the ancient Greek legal experience providing insights into the ongoing tension between individual conscience and state authority, the pursuit of impartiality and fairness and the role of law in shaping society and politics.

CONCLUSION

The ancient Greeks left an indelible mark on the world through their philosophy, art and literature but also their groundbreaking contributions to science, medicine and engineering. The intellectual curiosity and innovative spirit of the Greeks laid the foundation for many of the scientific and technological advancements that have shaped our modern world. From the development of geometry and the study of the cosmos to the establishment of medical practices and the construction of magnificent architectural wonders, the Greeks demonstrated a remarkable ability to observe, question and seek understanding of the world around them. Their pursuit of knowledge and their emphasis on rational thought and empirical evidence set the stage for the development of Western science and philosophy. To conclude this brief history, I want to explore some of this enduring legacy through the lens of these achievements, highlighting how their ideas and innovations continue to influence and inspire us to this day. By examining the impact of Greek thinkers and their contributions to these fields, we will gain a deeper appreciation of the profound and lasting influence of ancient Greek civilisation on the trajectory of human progress.

Science and Mathematics

Ancient Greek scientists and philosophers made significant strides in the fields of geometry, astronomy, cosmology and natural philosophy, laying the groundwork for modern scientific thought. The Greeks were among the first to adopt a rational and systematic approach to understanding the world around them, seeking to explain natural phenomena through observation, experimentation and deductive reasoning.

In geometry, the Greeks made remarkable contributions that continue to be taught and utilised today. Pythagoras, the famous Greek mathematician and philosopher, is credited with the discovery of the Pythagorean theorem, which states that in a right-angled triangle, the square of the hypotenuse is equal to the sum of the squares of the other two shorter sides of the triangle (though, while the theorem is named after Pythagoras, there is evidence that the concept was known and used by various civilisations, including the Babylonians, Egyptians, Indians and Chinese, well before Pythagoras's time). This theorem has far-reaching applications in mathematics, engineering and science. Euclid, another renowned Greek mathematician, wrote the influential treatise 'Elements', which served as the standard textbook for geometry for over two millennia. Euclid presented a systematic approach to geometry in this work, starting with simple definitions

and axioms and building up to more complex propositions and proofs.

The Greeks also made significant contributions to astronomy and cosmology. Aristarchus of Samos proposed a heliocentric model of the solar system, placing the Sun at the centre and the Earth and other planets orbiting around it. Although his ideas were not widely accepted at the time, they were later revived and refined by Copernicus and Galileo. Eratosthenes, a Greek mathematician and geographer, calculated the circumference of the Earth with remarkable accuracy using a simple yet ingenious method involving the angle of the Sun's rays at different locations on the Earth's surface. The Greeks were also among the first to develop the principles of deductive logic and reasoning. Aristotle formalised the syllogism, a form of logical argument in which a conclusion is derived from two premises. The Greeks emphasised the importance of clear definitions, precise language and logical argumentation, laying the foundation for developing formal logic and the scientific method.

In natural philosophy, the Greeks sought to understand the fundamental principles governing the natural world. Aristotle, one of the most influential thinkers in Western history, made significant contributions to the study of physics, biology and metaphysics. He developed the idea of the four elements (earth, water, air and fire)

and the concept of natural motion, positing that objects naturally tend to move towards their proper place in the universe. Although many of Aristotle's ideas were later overturned, his emphasis on observation and classification laid the foundation for the development of modern scientific methods.

Archimedes, a Greek mathematician, physicist and inventor, made groundbreaking contributions to geometry, mechanics and hydrostatics. He developed the concept of buoyancy and the principle of the lever, famously stating 'Give me a place to stand, and I shall move the Earth' (a quote much loved by American politicians, from Thomas Jefferson to John F. Kennedy and George Bush Senior). Archimedes also significantly advanced theorems of calculating the area and volume of geometric shapes, including the sphere and the cylinder.

Medicine and Anatomy

Ancient Greek physicians made significant contributions to the field of medicine, laying the foundation for modern medical practices. Among the most notable figures in Greek medicine was Hippocrates, often referred to as the 'father of medicine'. Hippocrates and his followers emphasised the importance of observing patients closely, recording their symptoms and medical histories, and using this information to make accurate diagnoses and develop

effective treatment plans. The Hippocratic Corpus, a collection of medical texts attributed to Hippocrates and his disciples, contains detailed descriptions of various diseases, along with their symptoms and treatments. The Hippocratic Oath, a code of ethics for physicians, stresses the importance of patient confidentiality, the proper use of medical knowledge and the avoidance of harm to patients. This oath, although modified over time, continues to be taken by many physicians today as a guiding principle for ethical medical practice.

Greek physicians also made significant advances in the study of anatomy and physiology. Herophilus and Erasistratus, two prominent Greek physicians from Alexandria, conducted extensive dissections of human cadavers, leading to a better understanding of the structure and function of the human body. Herophilus is credited with identifying the brain as the centre of the nervous system and distinguishing between motor and sensory nerves. Erasistratus made important discoveries about the circulatory system, recognising the role of the heart in pumping blood throughout the body.

In the field of pharmacy, Greek physicians developed a wide range of medicinal remedies derived from plants, minerals and animal products. Dioscorides, a Greek physician and pharmacologist, wrote an extensive treatise on *materia medica*, describing the properties and

uses of over six hundred medicinal substances. This work served as a standard reference for pharmacology for over fifteen hundred years.

Greek medical knowledge and practices had a profound influence on later medical practices not only in the Global North, but also in the early Islamic world. During the Islamic Golden Age, Muslim scholars translated and – crucially – built upon the works of Greek physicians, making significant contributions to the fields of medicine, pharmacy and anatomy. The Persian polymath Avicenna (Ibn Sina) wrote the influential *Canon of Medicine*, which incorporated and expanded upon Greek medical knowledge and remained a standard medical textbook in Europe for centuries. Greek medicine experienced a revival during the Renaissance, as scholars rediscovered and translated the works of ancient Greek physicians. The anatomical studies of Andreas Vesalius, a sixteenth-century Flemish anatomist, were heavily influenced by the works of Galen, a prominent Greek physician and anatomist. Vesalius's groundbreaking treatise *De Humani Corporis Fabrica* (On the Fabric of the Human Body) challenged and corrected many of Galen's anatomical misconceptions, paving the way for modern anatomical research.

The influence of Greek medicine can also be seen in the development of modern medical terminology. Many

medical terms and concepts have their roots in the Greek language, such as 'diagnosis' made of the Greek words 'dia', meaning through and 'gnosis' meaning knowledge, 'prognosis' ('pro' meaning before, 'gnosis' meaning knowledge), 'epidemic' ('epi' meaning among and 'demos' meaning the people) and 'pharmacology' ('pharmakon' meaning medicine or drug and 'logos' meaning study).

Architecture and Engineering
Ancient Greek architecture and engineering have left an indelible mark on the world, influencing building practices and design principles for centuries. The Greeks developed a unique architectural style characterised by harmony, proportion and balance, which found expression in three distinct architectural orders: Doric, Ionic and Corinthian.

The Doric order, the oldest and most austere of the three, is characterised by its simple, unadorned capitals and fluted columns. The Parthenon, a temple dedicated to the goddess Athena on the Acropolis in Athens, is perhaps the most famous example of the Doric order. The Ionic order, which originated in the cities of Ionia, features more slender and fluted columns with scrolled capitals. The Erechtheion, another temple on the Acropolis, showcases the Ionic order. The Corinthian order, the most ornate of the three, is distinguished by its elaborate

capitals decorated with acanthus leaves. The Temple of Olympian Zeus in Athens is a prime example of the Corinthian order. In theatre design, Greek architects created the amphitheatre, a semi-circular structure with tiered seating that provided excellent acoustics and sight-lines for the audience. The Theatre of Epidaurus, built in the fourth century BCE, is a stunning example of Greek theatre architecture, renowned for its perfect acoustics and harmonious design.

Greek architects and engineers made significant advances in the design and construction of public spaces and infrastructure. The *agora*, a central gathering place in Greek cities, served as a marketplace, a forum for public discourse, and a centre of social and political life. The Greeks also developed sophisticated systems for water management, including aqueducts, cisterns and drainage systems. The Tunnel of Eupalinos on the island of Samos, a remarkable feat of engineering, is a 1,036-metre-long tunnel constructed in the sixth century BCE to supply the city with water.

Greek advances in mechanics and engineering found application in both civilian and military contexts. Archimedes developed a range of mechanical devices, including the Archimedes screw, a machine for raising water, and the compound pulley, which made it easier to lift heavy loads. In the military sphere, the Greeks

developed sophisticated siege engines, such as catapults and battering rams, used to attack fortified cities.

The legacy of Greek architecture and engineering can be seen in the works of later civilisations, particularly the Romans and the architects of the Renaissance. Roman architects adopted and adapted Greek architectural principles, creating grand public spaces and monumental structures, such as the Pantheon and the Colosseum. During the Renaissance, architects, such as Andrea Palladio and Filippo Brunelleschi, drew inspiration from Greek and Roman architecture, incorporating Classical elements into their designs for palaces, churches and public buildings.

In urban planning, the Greek concept of the grid plan, in which streets are laid out in a regular, orthogonal pattern, had a lasting impact on the design of cities throughout the Western world. The Hippodamian plan, named after the Greek architect Hippodamus of Miletus, was characterised by a grid of straight streets intersecting at right angles, creating a rational and orderly urban layout. This approach to urban planning was widely adopted by the Romans and later by Renaissance and Enlightenment-era planners.

Social and Cultural

The impact of ancient Greek history and culture on modern society extends far beyond science, medicine,

architecture and engineering. Greek ideas and values have shaped so-called Western civilisation in profound ways, influencing our political systems, philosophical thought, literature, art and social norms. In politics, the ancient Greeks were the first to experiment with democracy, a system of government in which power is vested in the people. The Athenian democracy, although limited by modern standards, was a groundbreaking development in political thought, emphasising the importance of citizen participation, public debate and the rule of law. The ideas of Greek philosophers, such as Plato and Aristotle, on the nature of justice, the ideal form of government and the role of the citizen in society have had a lasting impact on Western political philosophy.

Greek literature and mythology have also profoundly influenced the Global North. The epic poems of Homer, *The Iliad* and *The Odyssey*, have inspired countless works of literature, art and film. Greek mythological figures and stories, such as the labours of Hercules, the tragedy of Oedipus and the adventures of Odysseus, have become part of our cultural lexicon, providing a rich source of allusion and symbolism for writers, artists and thinkers across the centuries. The Greeks were the first to develop the genres of tragedy and comedy in theatre. The works of Greek playwrights, such as Aeschylus, Sophocles, Euripides and Aristophanes, laid the foundation for

Western dramatic literature, exploring timeless themes of love, loss, fate and the human condition. The Greek concept of catharsis, the idea that theatre can provide a release of powerful emotions and a cleansing of the soul, has had a lasting impact on our understanding of the role of art in society.

Greek art and aesthetics have also had a profound influence on global culture, particularly in the Global North. The Greeks idealised the human form, creating sculptures and paintings that celebrated the beauty and proportions of the human body. The Greek concept of *symmetria*, the idea that beauty arises from harmonic proportions and balance, has shaped 'Western' aesthetic principles for centuries. Greek art and architecture have inspired countless imitations and adaptations, from the neoclassical buildings of the Enlightenment to the sculptures of Michelangelo and Rodin.

Finally, Greek philosophy has had an immeasurable impact on Western thought. The ideas of Socrates, Plato and Aristotle on the nature of reality, the purpose of life, the meaning of justice and the pursuit of happiness have shaped the course of Western intellectual history. Greek philosophical concepts, such as logic, ethics, metaphysics and epistemology have provided the foundation for centuries of philosophical inquiry and debate.

The ancient Greeks made enduring contributions to

virtually every field of human endeavour. Their intellectual curiosity, innovative spirit and passion for excellence laid the foundations for much of what we consider the bedrock of 'Western' thought and achievement. From the development of democracy and the birth of Western philosophy to the groundbreaking advancements in science, medicine, architecture and engineering, the Greeks left a permanent mark on the world that continues to inspire and shape our understanding of ourselves and our place in the universe.

The legacy of ancient Greece extends far beyond the confines of the Mediterranean world. Through the spread of Greek culture and language during the Hellenistic period, Greek ideas and values were transmitted to the far corners of the known world, influencing the development of civilisations from the Indus Valley to the Nile Delta. The complex synthesis of Greek, Egyptian, Persian and Indian cultures that emerged around the Mediterranean and along the Silk Road trade routes established a model of cultural hybridisation and cosmopolitanism that would shape the course of world history for centuries to come.

Today, we continue to engage with the ideas, values and achievements of the ancient Greeks as part of an ongoing conversation with a civilisation that has profoundly shaped our understanding of what it means to be human. By studying the art, literature, philosophy

and science of ancient Greece, we gain a deeper appreciation of the enduring power of human creativity, curiosity and the pursuit of knowledge. The ancient Greeks' legacy reminds us that the story of human civilisation is one of continuous learning, adaptation and the eternal quest for understanding. As we navigate the challenges and opportunities of our own time, we can draw inspiration and wisdom from the extraordinary achievements of this remarkable culture, which continue to shed light on the fundamental questions of existence and the boundless potential of the human spirit.

TIMELINE

1. Bronze Age (c. 3000–1100 BCE)
 - Minoan civilisation (c. 3000–1450 BCE)
 » Centred on the island of Crete
 » Known for its elaborate palaces, frescoes and linear A script
 - Mycenaean civilisation (c. 1600–1100 BCE)
 » Centred on the Greek mainland, particularly in Mycenae
 » Known for its fortified citadels, linear B script and epic poetry
 - Collapse of Bronze Age civilisations (c. 1200–1100 BCE)
 - Possible causes: climate change, invasions, social upheaval

2. Greek Dark Ages (c. 1100–800 BCE)
 - Cultural and economic decline following the collapse of Bronze Age civilisations
 - Development of Greek language and mythology

- Emergence of the Greek alphabet (adapted from the Phoenician alphabet)

3. Archaic Period (c. 800–480 BCE)
 - Rise of the polis (city-state) as the central unit of Greek political and social life
 - Greek colonisation of the Mediterranean and Black Sea regions (c. 800–600 BCE)
 - Establishment of colonies in modern-day Italy, France, Spain, Libya, Turkey and Ukraine
 - Age of Tyrants (c. 650–500 BCE)
 - Rule of powerful individuals in many Greek city-states
 - Emergence of Greek literature
 - Homer's epics (*The Iliad* and *The Odyssey*) composed (c. 750–700 BCE)
 - Hesiod's works (*Theogony* and *Works and Days*) composed (c. 700 BCE)
 - Lyric poetry (Sappho, Alcaeus, Anacreon) flourishes (c. 600–500 BCE)
 - Rise of Greek art and architecture
 - Development of Doric and Ionic orders (c. 600 BCE)
 - Monumental sculpture and temple architecture

4. Classical Period (c. 480–323 BCE)
 • Persian Wars (499–449 BCE)
 • Ionian Revolt (499–494 BCE)
 • First Persian invasion of Greece
 (492–490 BCE)
 • Battle of Marathon (490 BCE)
 • Second Persian invasion of Greece
 (480–479 BCE)
 • Battle of Thermopylae (480 BCE)
 • Battle of Salamis (480 BCE)
 • Battle of Plataea (479 BCE)
 • Battle of Mycale (479 BCE)
 • Rise of Athenian democracy
 • Reforms of Cleisthenes (508 BCE)
 • Age of Pericles (c. 461–429 BCE)
 • Construction of the Parthenon (447–432 BCE)
 • Golden Age of Athens (c. 480–404 BCE)
 • Greek drama
 » Aeschylus (c. 525–456 BCE)
 » Sophocles (c. 497–406 BCE)
 » Euripides (c. 480–406 BCE)
 » Aristophanes (c. 446–386 BCE)
 • Greek philosophy
 » Socrates (c. 470–399 BCE)
 » Plato (c. 428–348 BCE)
 » Aristotle (384–322 BCE)

- Greek history
 - » Herodotus (c. 484–425 BCE)
 - » Thucydides (c. 460–400 BCE)
- Greek art and architecture
 - » Phidias (c. 480–430 BCE)
 - » Polykleitos (c. 450–420 BCE)
 - » Praxiteles (c. 395–330 BCE)
- Peloponnesian War (431–404 BCE)
- Conflict between Athens and Sparta (and their respective allies)
- Ended in Spartan victory and the decline of Athenian power
- Rise of Macedon
- Reign of Philip II (359–336 BCE)
- Conquest of Greece (338 BCE)
- Conquests of Alexander the Great (334–323 BCE)
 - » Defeats the Persian Empire
 - » Establishes an empire stretching from Greece to India
 - » Dies in Babylon (323 BCE)

5. Hellenistic Period (c. 323–31 BCE)
 - Wars of the Diadochi (322–281 BCE)
 - Conflicts among Alexander's generals (Ptolemy, Seleucus, Antigonus, Cassander)

- Division of Alexander's empire into successor states
- Ptolemaic dynasty in Egypt (305–30 BCE)
 » Centred in Alexandria
 » Famous rulers: Ptolemy I Soter, Cleopatra VII
- Seleucid Empire in Persia and Mesopotamia (312–63 BCE)
 » Centred in Antioch and Seleucia
 » Famous rulers: Seleucus I Nicator, Antiochus III the Great
- Antigonid dynasty in Macedon (306–168 BCE)
 » Centred in Pella
 » Famous rulers: Antigonus I Monophthalmus, Demetrius I Poliorcetes
- Spread of Greek culture and language (Hellenisation)
- Greek becomes the lingua franca of the Eastern Mediterranean
- Fusion of Greek and local cultural elements
- Advances in science, mathematics and technology
 » Euclid (c. 300 BCE) – geometry
 » Archimedes (c. 287–212 BCE) – physics, engineering
 » Eratosthenes (c. 276–194 BCE)

- geography, astronomy
 - » Hipparchus (c. 190–120 BCE) – astronomy, trigonometry
- Development of new philosophical schools
 - » Stoicism – founded by Zeno of Citium (c. 300 BCE)
 - » Epicureanism – founded by Epicurus (c. 307 BCE)
 - » Scepticism – founded by Pyrrho (c. 360–270 BCE)
- Expansion of Greek trade and commerce
 - » Growth of the Silk Road connecting the Mediterranean with Central and East Asia
- Conflicts with rising powers
 - » Wars with the Roman Republic (215–148 BCE)
 - » Conquest of Ptolemaic Egypt by Rome (31 BCE)

6. Roman Greece (c. 146 BCE–330 CE)
 - Greece under Roman rule
 - Becomes a province of the Roman Empire
 - Retains a degree of autonomy and cultural distinctiveness
 - Influence of Greek culture on Roman art,

literature and philosophy
- Roman adoption and adaptation of Greek gods, myths and artistic styles
- Greek influence on Latin literature (e.g. Virgil, Ovid)
- Influence of Greek philosophy on Roman thought (e.g. Cicero, Seneca)
- Spread of Christianity in Greece
- Apostle Paul's missionary journeys (c. 50–60 CE)
- Establishment of early Christian communities in Greek cities
- Division of Roman Empire (330 CE)
- Emperor Constantine I founds Constantinople (modern-day Istanbul) as the new capital of the Eastern Roman Empire
- Greece becomes part of the Eastern Roman (Byzantine) Empire
- Continued influence of Greek culture and language in the Byzantine world

GLOSSARY

Acropolis: The citadel of an ancient Greek city, typically built on a hill.

Aeschylus: An ancient Greek tragedian, known for plays, such as *The Oresteia*.

Agora: The central public space in ancient Greek city-states, serving as a marketplace and gathering place.

Anaximander: A Pre-Socratic philosopher from Miletus, known for his theories about the origin of the cosmos.

Apeiron: The boundless or infinite, a concept introduced by Anaximander.

Apotheosis: the elevation of a mortal to immortality.

Archimedes: A Greek mathematician, physicist and inventor from Syracuse.

Aristophanes: An ancient Greek comic playwright, known for works, such as *The Clouds* and *Lysistrata*.

Aristotle: A Greek philosopher and polymath, student of Plato and teacher of Alexander the Great.

Athena: The ancient Greek goddess of wisdom, war and crafts.

Attica: The region of Greece that includes Athens.

Cleisthenes: An ancient Athenian statesman, known for his reforms that established democracy in Athens.

Deme: A political division or municipality in ancient Athens.

Demeter: The ancient Greek goddess of agriculture, fertility and the harvest.

Demokratia: The ancient Greek term for 'democracy'.

Dionysus: The ancient Greek god of wine, theatre and ecstasy.

Doric Order: One of the three orders of ancient Greek architecture, characterised by its simplicity and austerity.

Draco: An ancient Athenian lawgiver, known for his harsh code of laws.

Ekklesia: The principal assembly of ancient Athens, open to all male citizens.

Ephialtes: An Athenian politician who played a key role in the reforms of 462 BCE, which shifted power from the Areopagus to the Ekklesia.

Eratosthenes: A Greek mathematician, geographer and astronomer, best known for calculating the Earth's circumference.

Euclid: A Greek mathematician, often referred to as the 'founder of geometry'.

Euripides: An ancient Greek tragedian, known for plays, such as *Medea* and *The Bacchae*.

Gerousia: The council of elders in ancient Sparta.

Heliaia: The supreme court of ancient Athens.

Helots: The state-owned serfs of ancient Sparta.

Hera: The ancient Greek goddess of marriage and family.

Heracles (Hercules): A divine hero in Greek mythology, known for his strength and Twelve Labours.

Herodotus: An ancient Greek historian, often considered the 'father of history'.

Hesiod: An ancient Greek poet, known for works, such as *Theogony* and *Works and Days*.

Hippocrates: An ancient Greek physician, often considered the 'father of medicine'.

Homer: The legendary ancient Greek epic poet, attributed with *The Iliad* and *The Odyssey*.

Hoplite: A heavily armed ancient Greek foot soldier.

Ionia: A region of central coastal Anatolia (modern-day Turkey) in ancient Greece.

Ionic Order: One of the three orders of ancient Greek architecture, characterised by its elegance and ornate style.

Kore (Korai): A type of ancient Greek sculpture depicting a clothed female figure.

Kouros (Kouroi): A type of ancient Greek sculpture depicting a standing nude male youth.

Lycurgus: The legendary lawgiver of ancient Sparta.

Metic: A foreign resident in an ancient Greek city-state, with limited rights.

Odysseus: The hero of Homer's *The Odyssey*, known for his intellect and cunning.

Oikos: The ancient Greek household or family unit.

Oligarchy: A form of government in which power is held by a small group of people.

Paideia: The ancient Greek system of education and upbringing.

Parthenon: The temple dedicated to Athena on the Acropolis of Athens.

Peloponnesian War: The war between Athens and Sparta (431–404 BCE).

Pericles: A prominent Athenian statesman, orator and general during the Golden Age of Athens.

Plato: An ancient Greek philosopher, founder of the Academy in Athens and author of philosophical works, such as *The Republic*.

Polis (Poleis): The ancient Greek city-state.

Protagoras: An ancient Greek sophist and philosopher, known for his relativist views.

Pythagoras: An ancient Greek philosopher and mathematician, known for the Pythagorean theorem.

Rhetoric: The art of persuasive speaking and writing, highly valued in ancient Greece.

Socrates: An ancient Greek philosopher, known for his method of questioning and his emphasis on ethics and moral reasoning.

Solon: An Athenian statesman, lawmaker and poet, known for his reforms that laid the foundation for Athenian democracy.

Sophist: A professional teacher and intellectual in ancient Greece, often associated with relativism and persuasive speaking.

Sophocles: An ancient Greek tragedian, known for plays, such as *Oedipus Rex* and *Antigone.*

Strategos (Strategoi): A military general and political leader in ancient Athens.

Symposium: An ancient Greek drinking party, often accompanied by music, dancing and intellectual discussion.

Thales: A Pre-Socratic philosopher from Miletus, known for his theories about the nature of the world.

Thucydides: An ancient Greek historian and general, known for his work, *History of the Peloponnesian War.*

Tyranny: A form of government in which a single ruler holds absolute power.

Xenia: The ancient Greek concept of hospitality, involving the reciprocal relationship between host and guest.

Zeus: The supreme god in ancient Greek religion, ruler of the Olympian gods.